BUCKAROO BOOTS

JIM ARNDT

GIBBS SMITH
TO ENRICH AND INSPIRE HUMANKIND

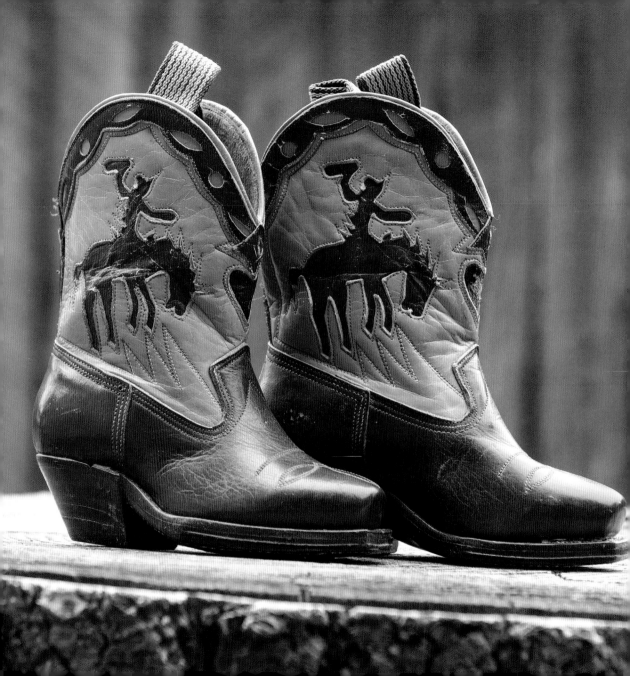

CONTENTS

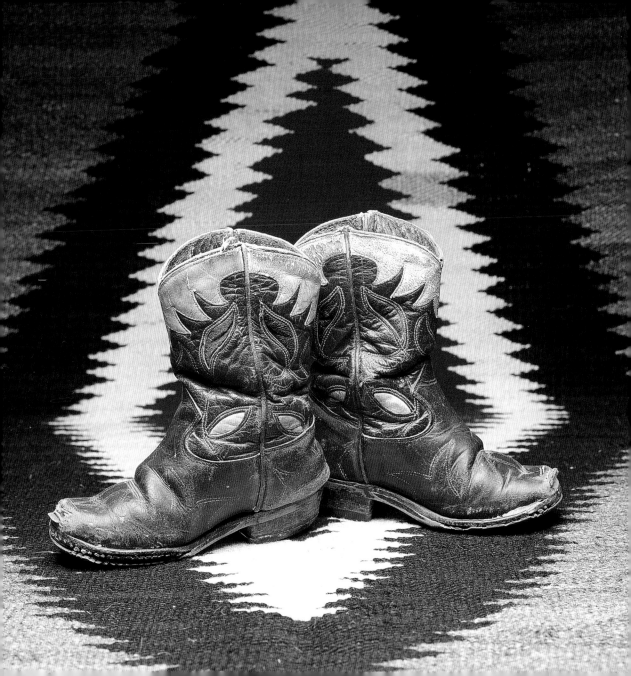

Acknowledgments

Thanks to all the talented boot makers, past and present. A big thank-you to Madge, editor extraordinaire, for her consistent faithfulness and Melissa for her design talent. A huge thank-you and love to Kathy Graves, wordsmith, for helping her little brother.

Thanks, Uncle Harold Laurence, for putting me in my first boots and inspiring me to go western.

To the boot collectors, thank you: Allen Wilkinson, awesome bootist, and Amy Park; Wendy Lane Henry for her decades of boot passion and Back at the Ranch; Cowden Henry; Mike Cavender for his amazing collection and dedication to boot history; Cooper Cavender; the Bennett brothers, Jim and John, for keeping the spirit of the West alive;

Martha and Wilson Franklin and all the family at M.L. Leddy; Dave and Sharon Little, boot makers extraordinaire. Keeping the spirit alive: Ronnie Dunn, Johnny Hallyday, Marty Stuart, and John Ware. Cowboy inspiration: Clint and Wyatt Mortenson, Teal and Joncee Blake, James Thompson, Richard Stump, Jack Pressler, Mark Hooper, Lee Downey, Pedro Muñoz, Roxanne Thurman, and Bill Reynolds. Thanks to the bootmen: Tyler Beard and the Professor of Bootology Evan Voyles.

Most of all, thank you to my partner, my friend, my western inspiration, my girl, Nathalie, always in her cowboy boots, for all her love and support.

FACING: *A pair from Tyler Beard's childhood.*

Introduction

From the days of the silver screen, cowboys caught people's imagination—both the lawmen and the outlaws. In movies and on TV, we watched cowboys round up thousands of head of cattle, confident upon their horses, their spurs and shouted commands directing their steeds, lassos twirling. If fortunate, we even had opportunities to attend rodeos, where cowboys walked tall, rode strong, and fell hard.

Singing cowboy stars such as Roy Rogers (and his cowgirl Dale Evans), Gene Autry, Tex Ritter, and Bob Wills won our admiration. Non-singing cowboys became just as popular for their

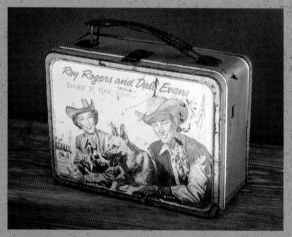

daring feats and law-abiding ways—The Lone Ranger, Hopalong Cassidy, and, of course, The Duke, John Wayne. Even a favorite puppet television star, Howdy Doody, and his pal Buffalo Bob both wore cowboy outfits. Children wanted to dress as their heroes did! Our fantasy was to ride the range, herd cattle, rope and brand, confront rustlers and bank robbers; and even in our imaginations, we could not do this without the appropriate attire. A new market in children's clothing was born.

We were willing to save our allowances to buy a pair of cowboy boots but, oh, that would take so

long. We searched the Sears Roebuck catalogs and circled the boots and western clothes, then crossed our fingers before birthdays and Christmas, hoping to find our picks in a gift-wrapped box.

At bedtime, we wanted to sleep with our boots on, because that's what we heard that real cowboys did. When Mom insisted that we take them off, we carefully placed them on the floor next to the bed. Perhaps we had scuffed them up, intentionally or not, so we would not look like a tenderfoot.

Many a young cowboy or cowgirl followed their dream into adulthood, at least in terms of their favorite footwear. Figuratively or literally, we walk, work, ride, sing, dance and live in our boots, just as our acting, singing, roping and riding cowboy heroes did.

In these pages are well-worn vintage boots and contemporary designs to fire the imagination and carry little feet into the corral and across the open fields. Cute-as-can-be, small-scale boots for little cowboy and cowgirl feet, are proportioned just like their grown-up counterparts, complete with inlaid and over-laid designs and bold colors!

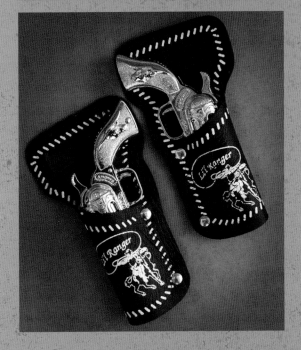

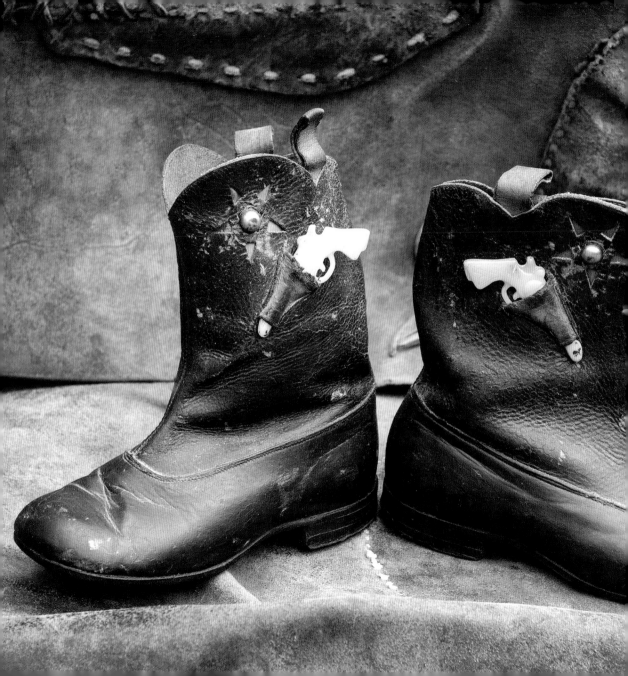

Almost Boots

From day one, putting your new cowgirl or cowboy in their first pair of boots is on your mind. Get the look right and get it going. Toddler boots are a combination of boots and baby shoes with a mostly flat bottom. No big, tall, underslung heels for these tip-over little people. With boots, there are no laces to tie or trip on.

Let your babies grow up to be cowboys!

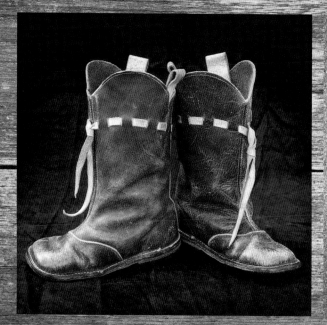

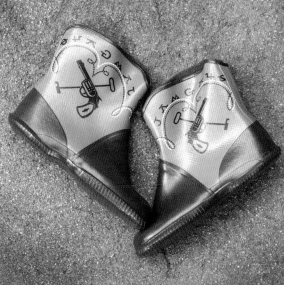

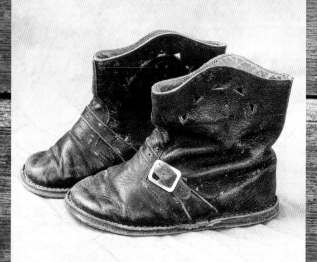

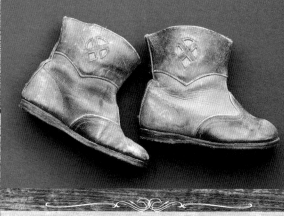

Some slip-ons: part shoe, part moccasin, and almost cowboy boots.

ABOVE: *The western theme is printed on these rain boots.*

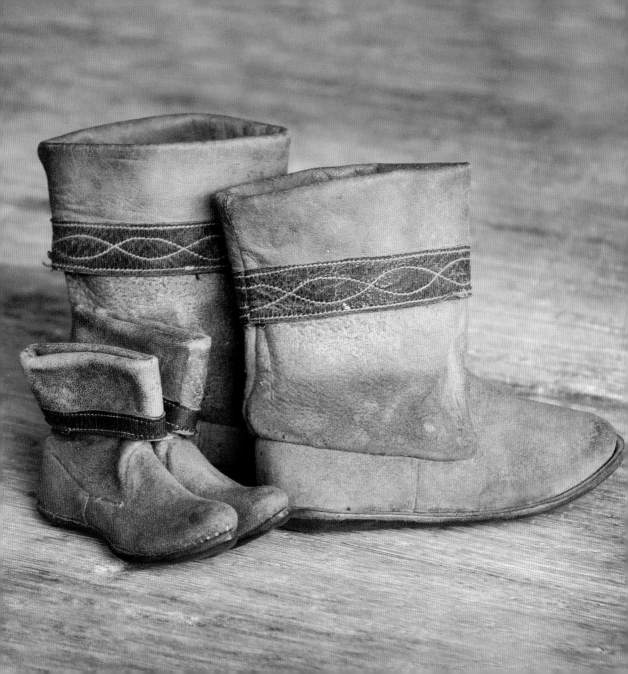

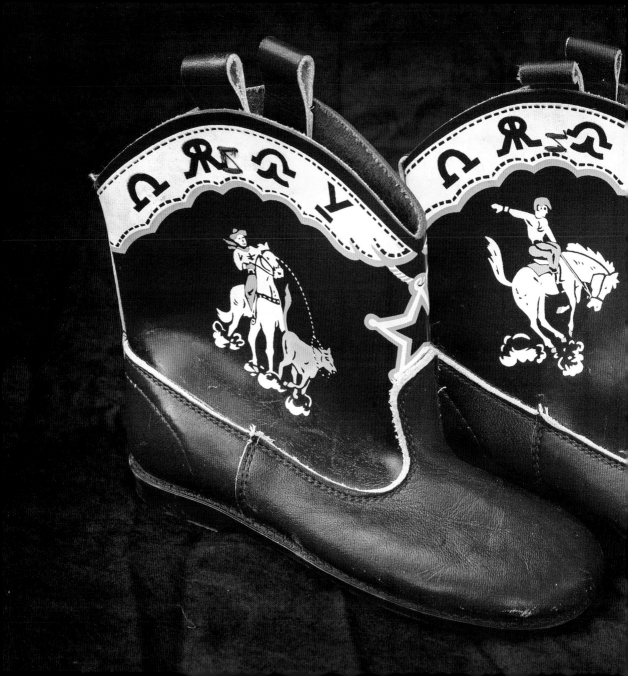

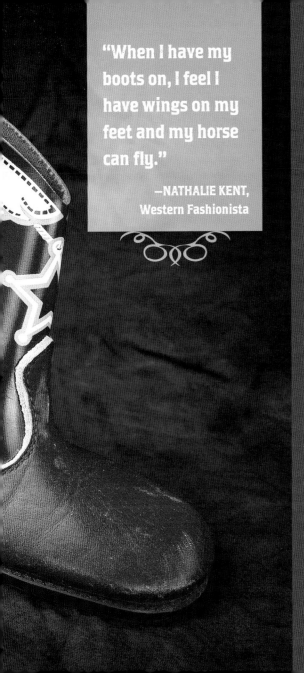

> "When I have my boots on, I feel I have wings on my feet and my horse can fly."
>
> —NATHALIE KENT,
> Western Fashionista

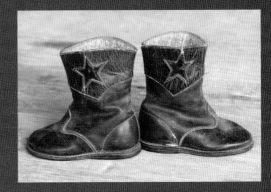

Stars were very popular on early cowboy boots, for little people or big. The star may have been one of the first boot inlays. Below, Nathalie Kent gets early practice on a horse.

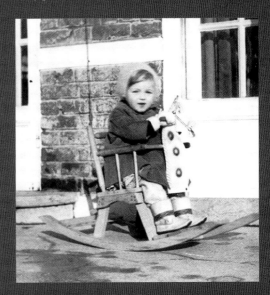

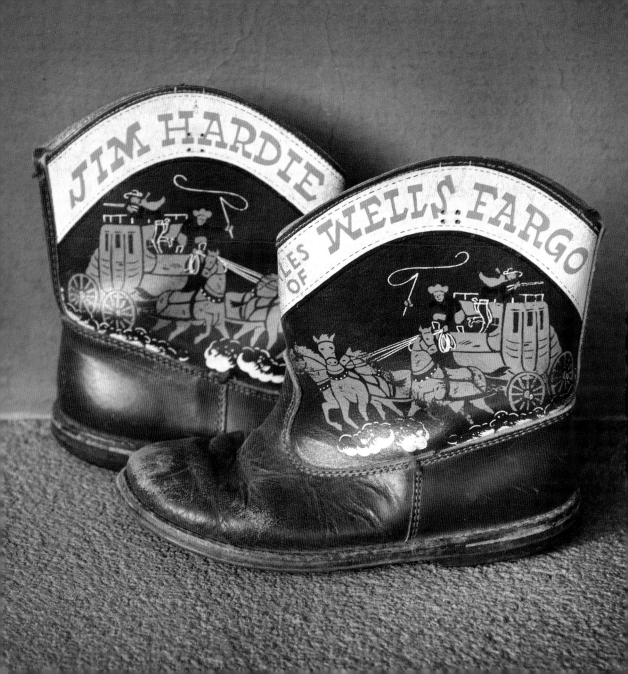

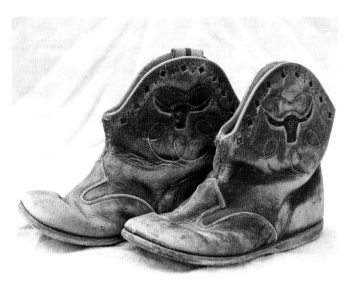

Being linked to television shows like Tales of Wells Fargo *and* The Roy Rogers Show *sold many a pair of boots. Longhorns and cutouts added style.*

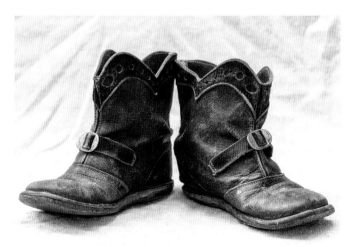

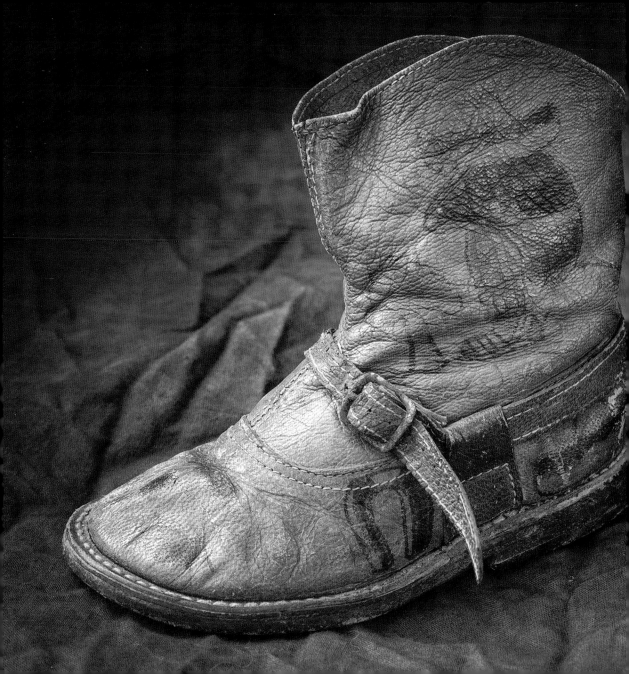

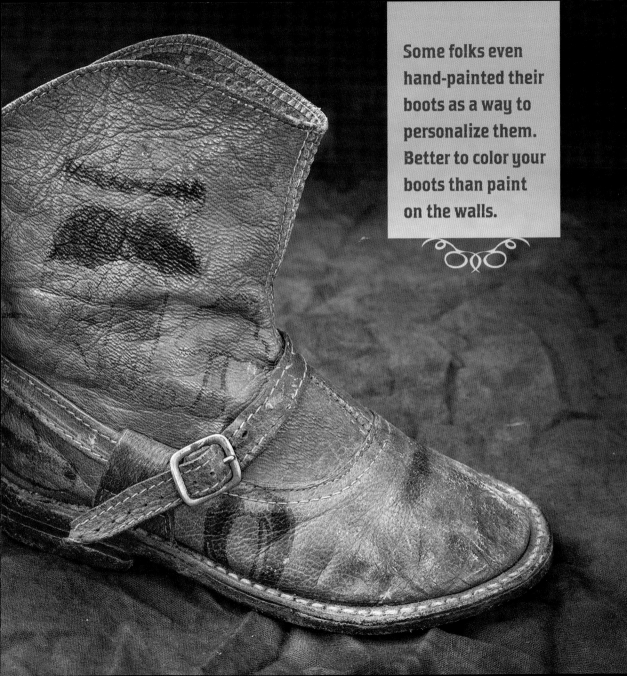

Some folks even hand-painted their boots as a way to personalize them. Better to color your boots than paint on the walls.

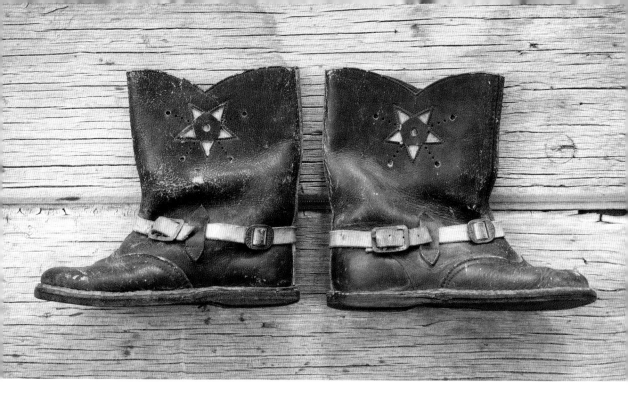

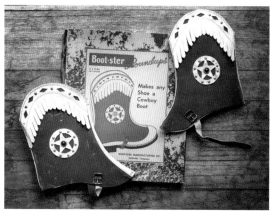

If brown with stars, printed patterns, embossing or zippers didn't fill the bill, you could buy the "Boot-ster" to strap onto a kid's shoes to make any pair look like boots.

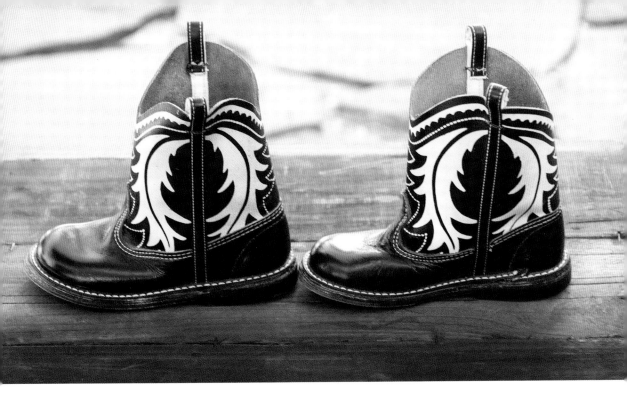

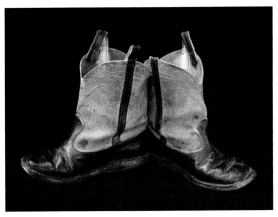

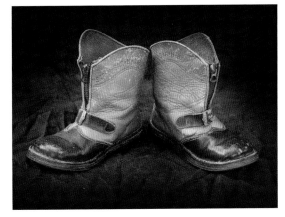

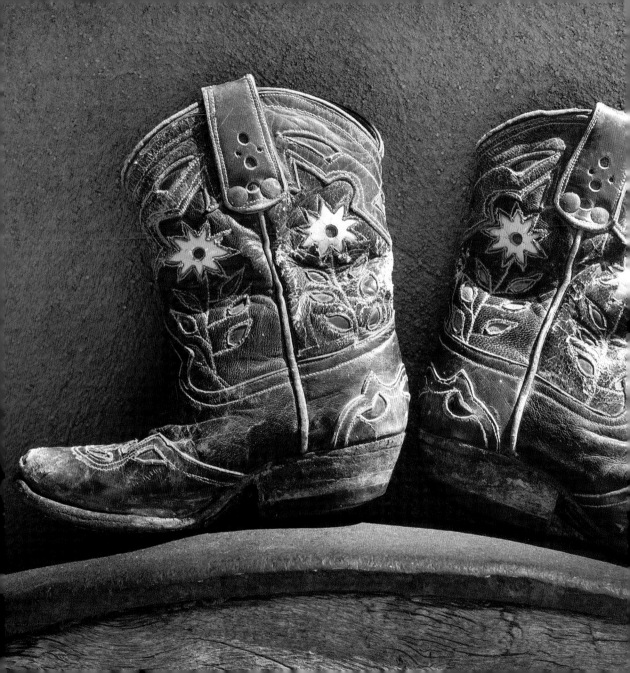

Basic in
Black & Brown

In the beginning, cowboy boots were either black or brown leather because that was the color of the steer hides the leather came from. By the time movie cowboys came along, boot makers had begun to use colored leathers, dyes, and artistic ingenuity to their products.

Maybe a child's boots were still basic black or brown, but they didn't need to be any less fancy than their colorful counterparts. Some flowers, cactuses, stars, stamping or embossing can distinguish a classic boot for a classy young'un.

Basic brown or black were jazzed up with a blue eagle, a red longhorn, or inlaid scrolls.

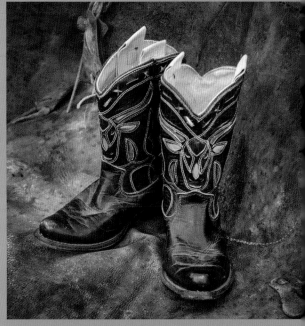

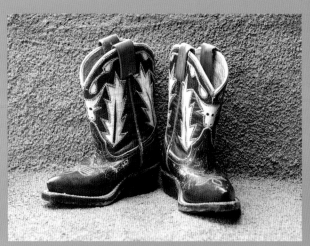

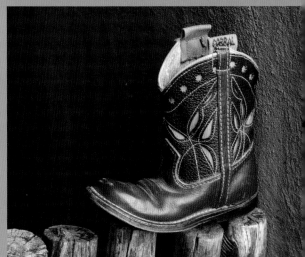

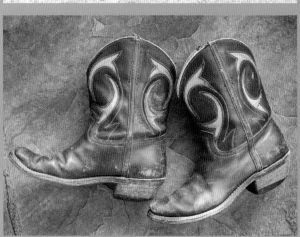

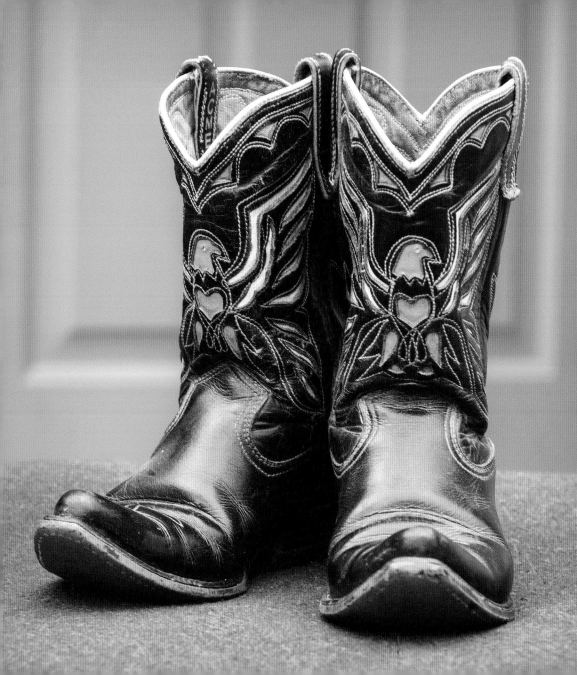

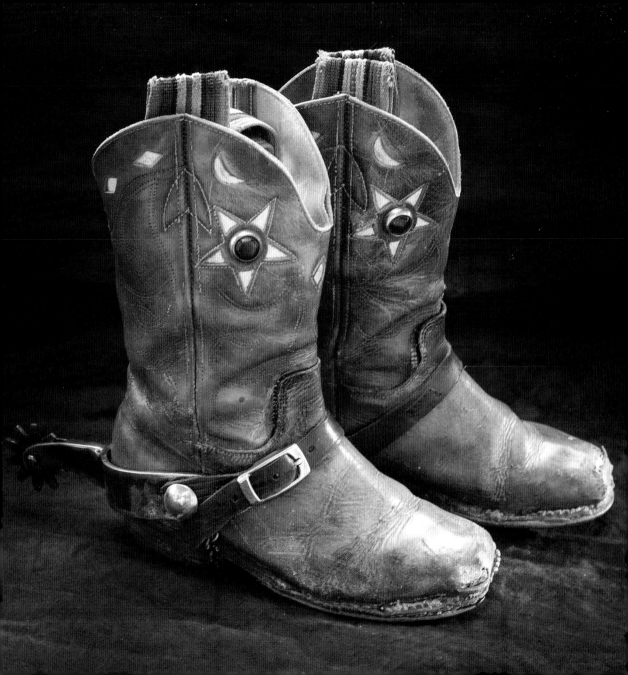

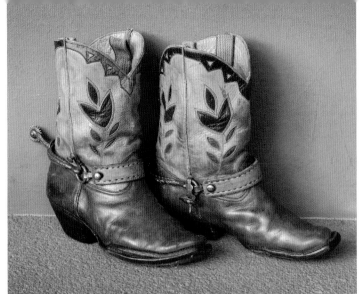

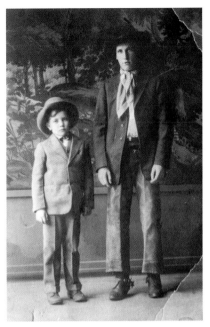

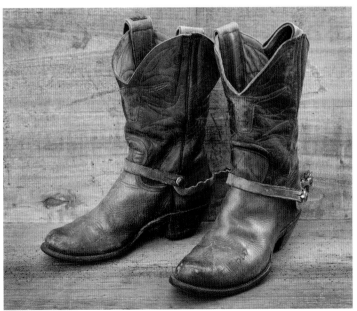

Putting spurs on your boots added a western cowboy feel—and a kick!

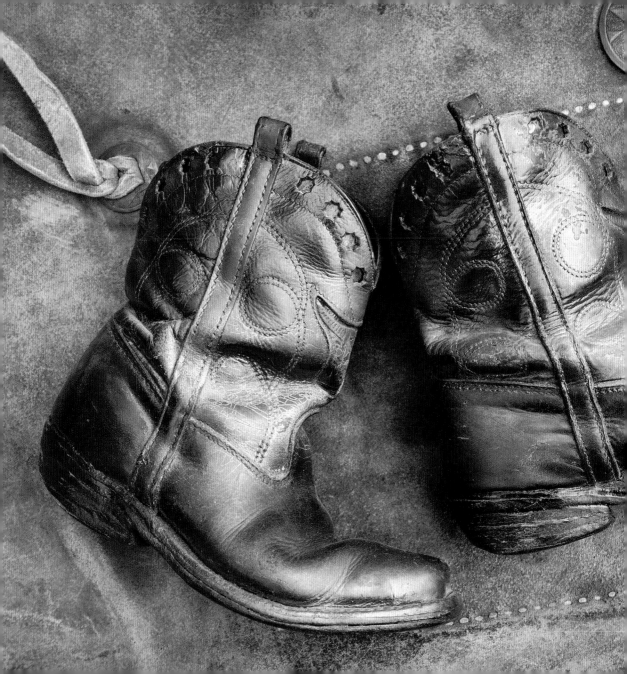

Some clever person thought paint would freshen up these oldies.

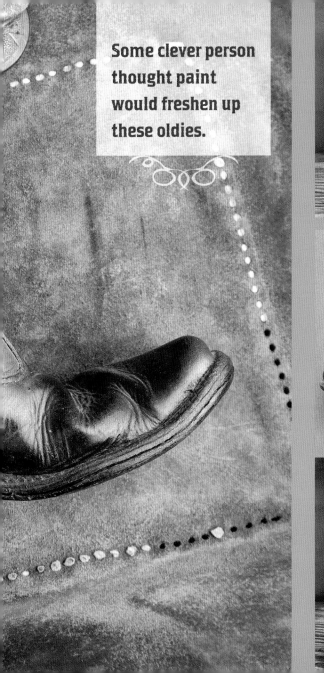

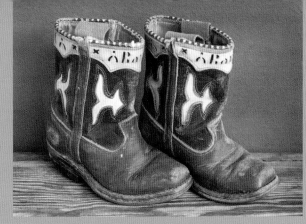

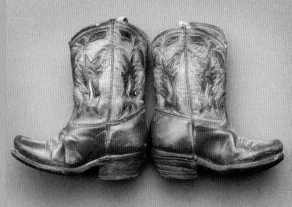

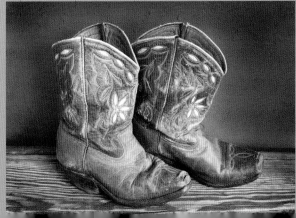

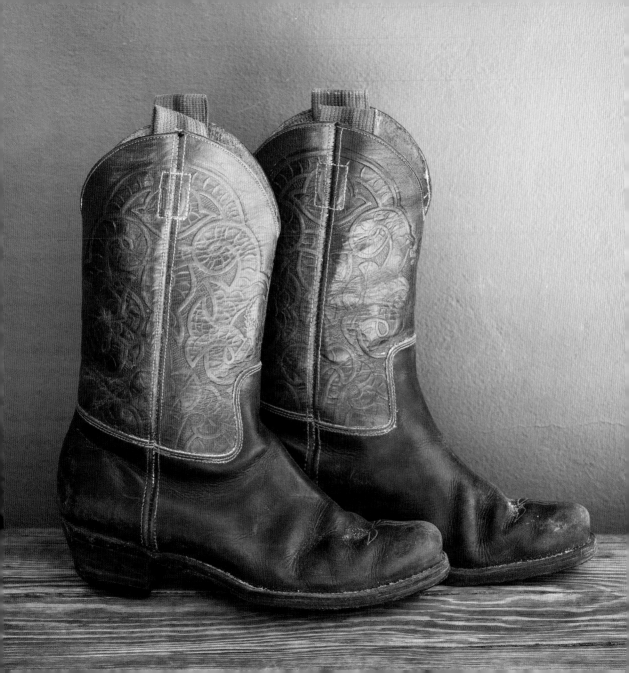

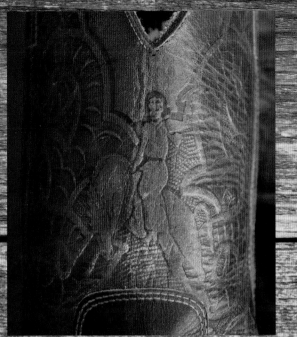
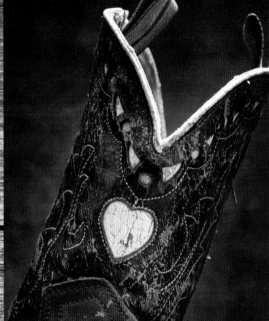

"My uncle Harold gave me my first pair of cowboy boots when I was five years old. I never wanted to take them off. Oh, wait. I have never worn anything else since. Guess I must have a hundred pair by now."

—JIM ARNDT

These early boots had an embossed pattern on the uppers, adorned with a lovely cowgirl on her buckin' bronc.

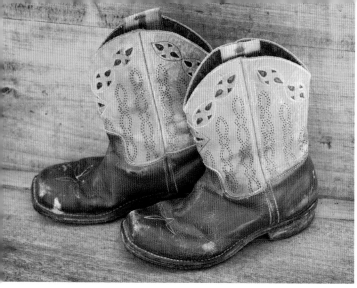

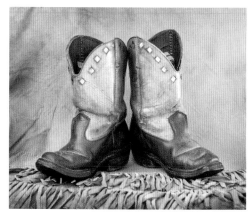

The addition of cutouts along with some fake stitching or an embossed pattern elevated these everyday boots.

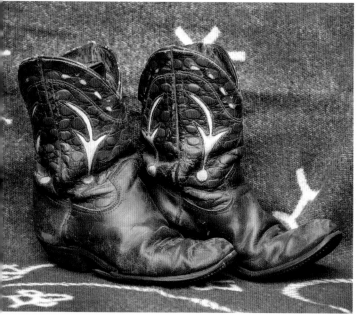

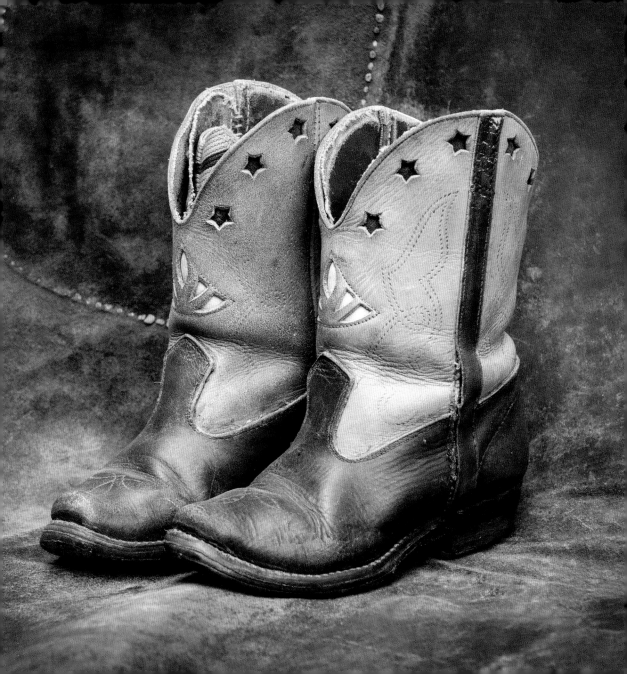

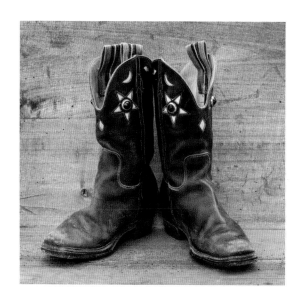

"Shoot low, I'm riding a Shetland."

—JAMES THOMPSON,
Boot Lover

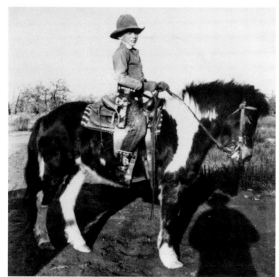

FACING: *These 1950s black and white boots with diamond cutouts and stitching look like they should be worn with a tuxedo!*

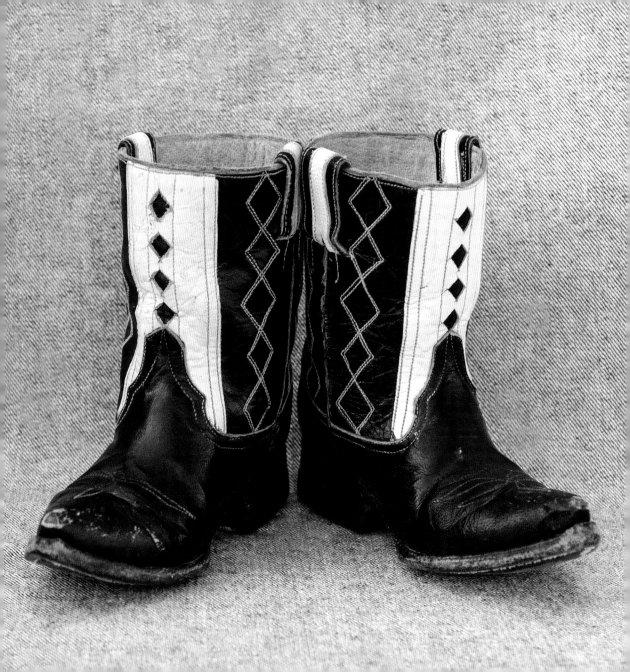

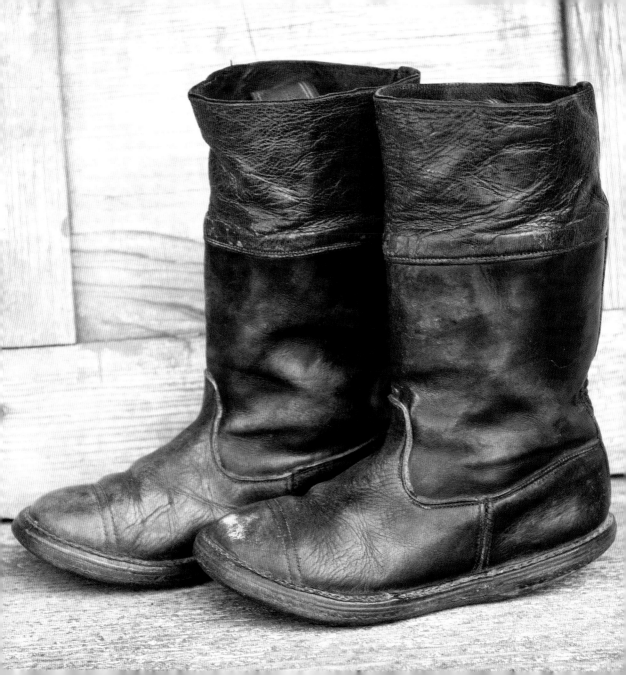

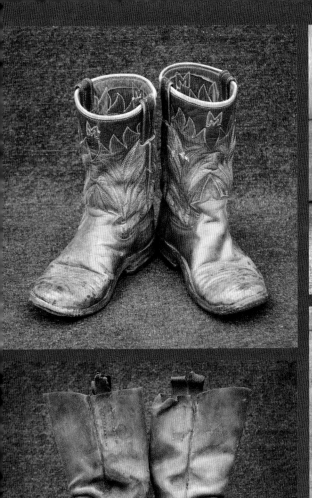

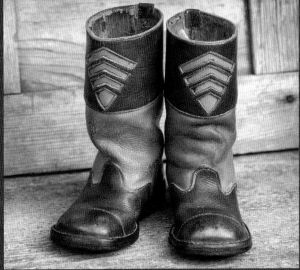

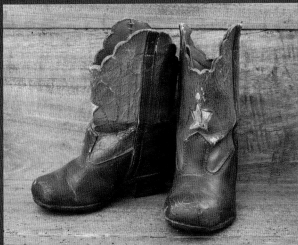

LEFT: *An early example of a Civil War–era boot. This style was emulated in later boots. Cavalry-style chevrons show up quite often, as do red-over-black designs.*

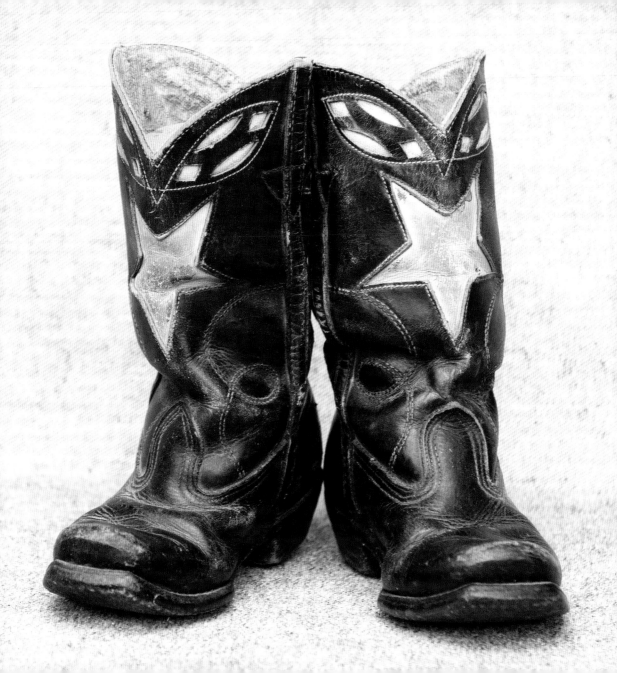

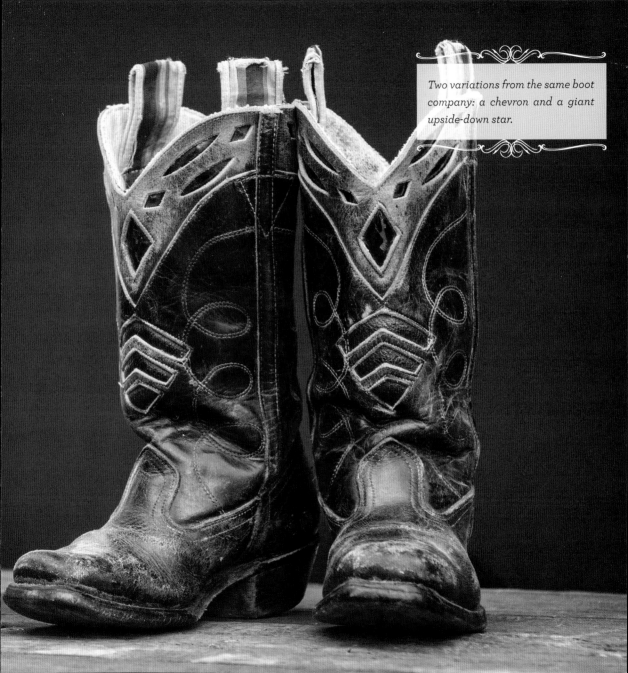

Two variations from the same boot company: a chevron and a giant upside-down star.

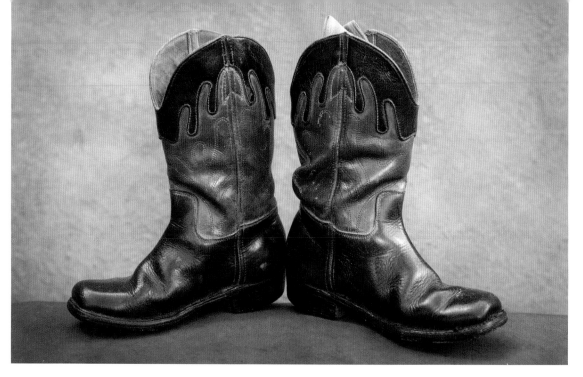

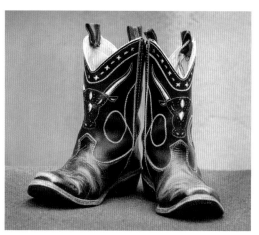

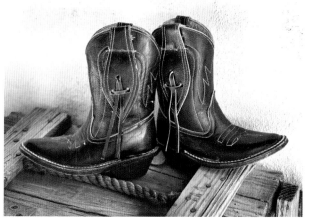

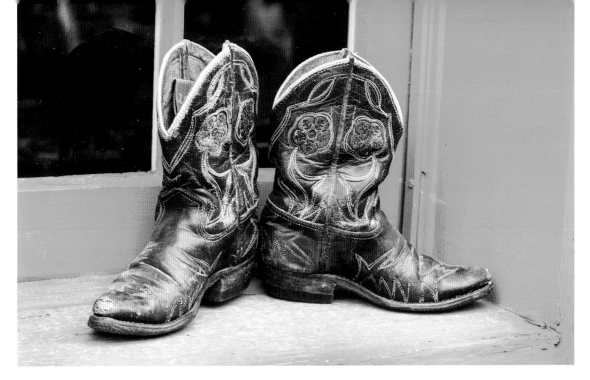

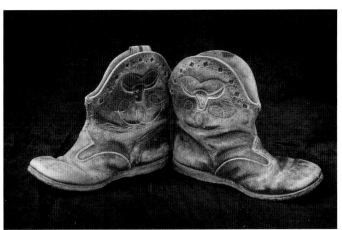

FACING ABOVE: *The "dripping wax" pattern has an unknown origin, although this pair is not an isolated one-of-a-kind.*

Side lacing on mini mule ears is less common than flowers and the ever-present longhorn.

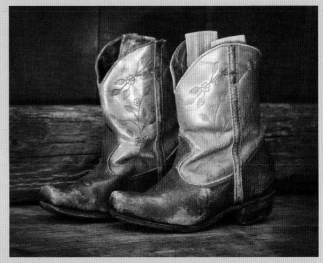

RIGHT AND FACING: *Embossed flowers with an embossed toe bug.*

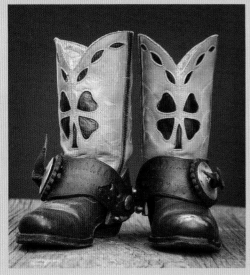

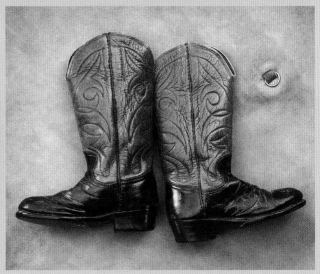

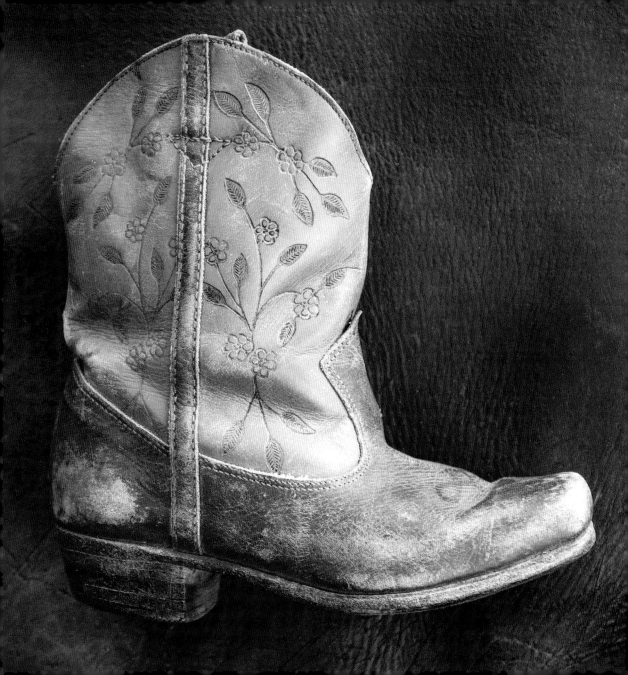

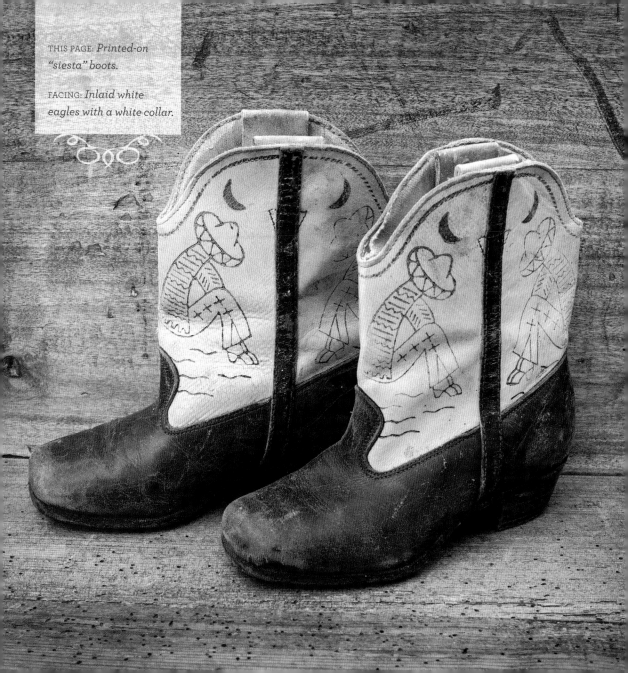

THIS PAGE: *Printed-on "siesta" boots.*

FACING: *Inlaid white eagles with a white collar.*

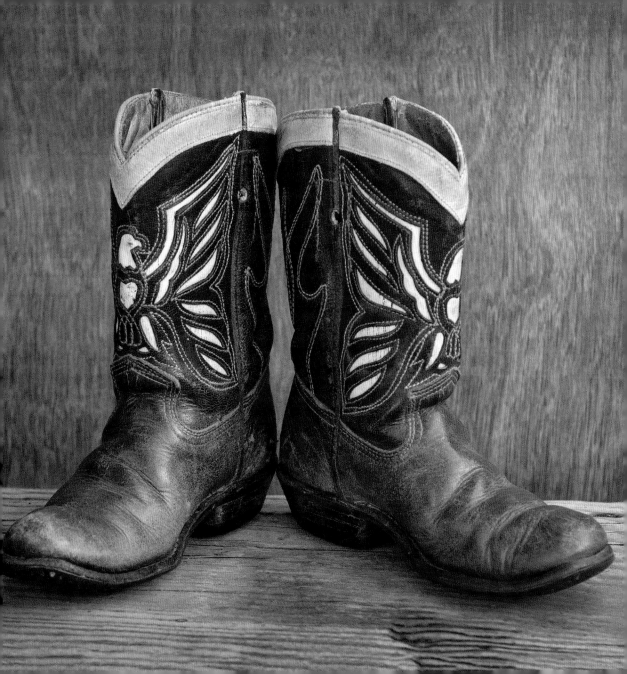

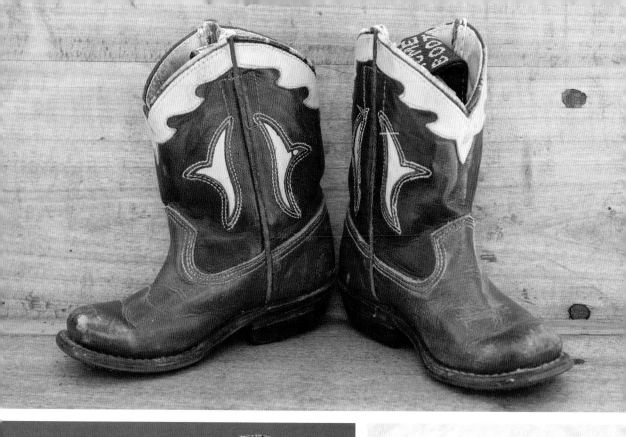

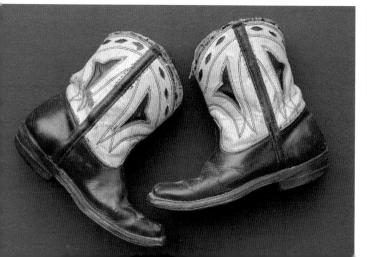

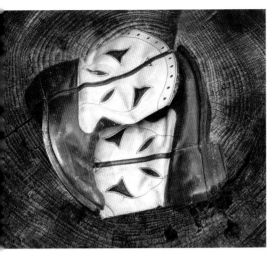

The boots are basic, but cutout patterns, a few stars, a little stitching, and a splash of color change all that.

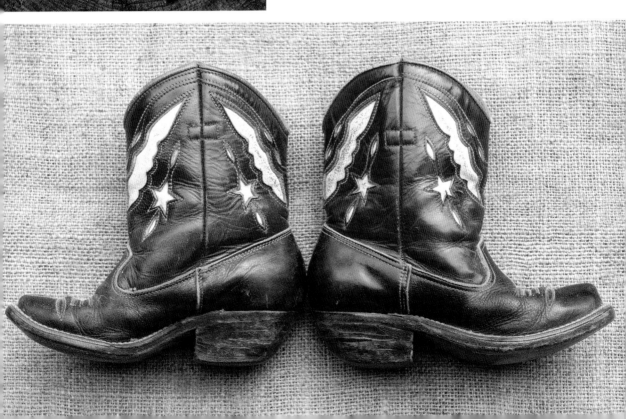

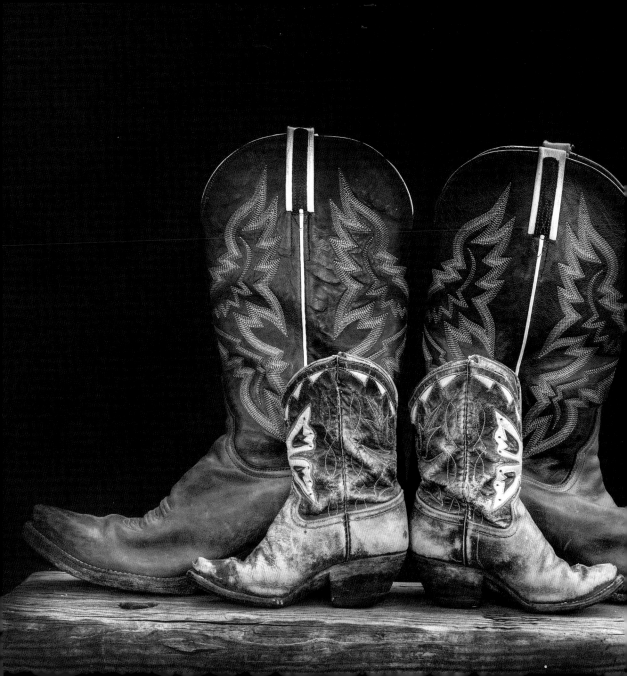

Cowkid Dreamin'

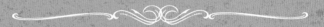

Those cowboy heroes of movies and TV inspired us to be like them. Hiding behind the tree in the backyard with our six-shooters, hat and boots, we chased bad guys and protected our piece of land. If we could have a pair of Hopalong Cassidy, Roy Rogers, Tom Mix, Gene Autry, 101 Ranch, or fancy Acmes, we instantly felt fierce, loyal, tough and invincible.

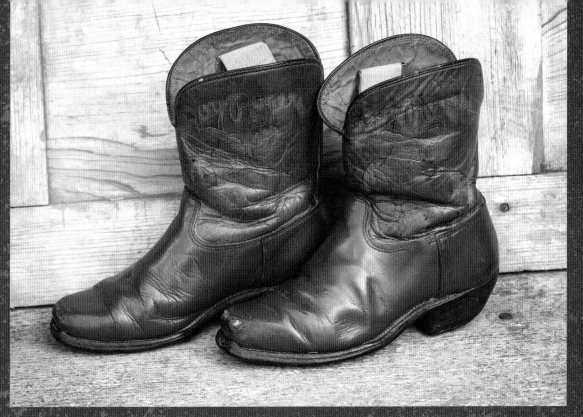

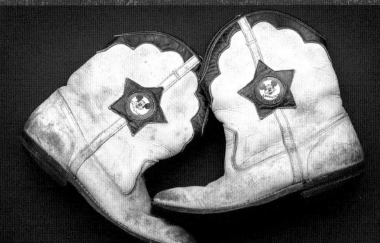

FACING: *Today's collectors want not only the boots but preferably the original packaging, advertising, matching gloves and all the accoutrements.*

ABOVE: *Now-faint embossing on the leather uppers shows Roy Rogers on Trigger.*

LEFT: *Mickey Mouse badges adorn these white kiddie boots.*

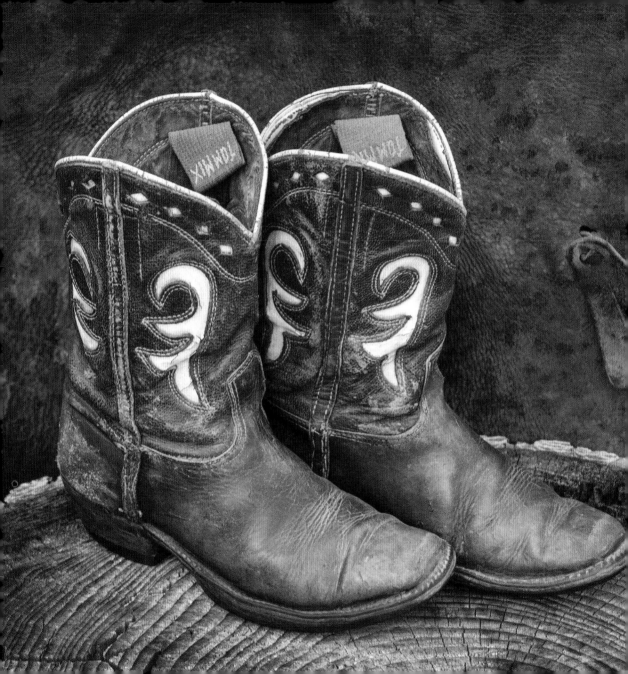

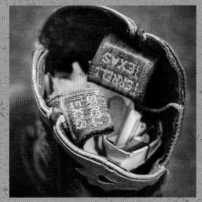

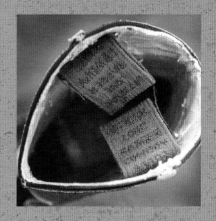

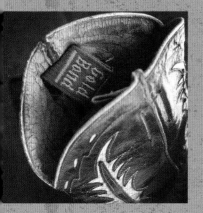

Boot collectors first look inside a boot for the maker's name or logo, which is usually printed on the cloth pulls. Some of the famous children's boots are labeled Roy Rogers, Gene Autry, Tom Mix, and Hopalong Cassidy.

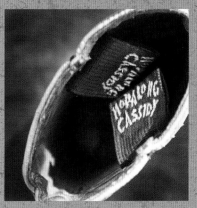

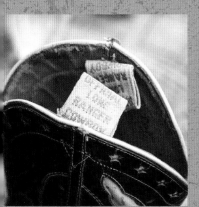

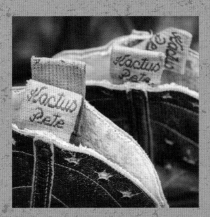

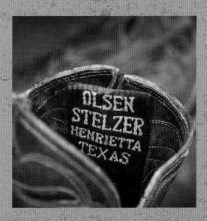

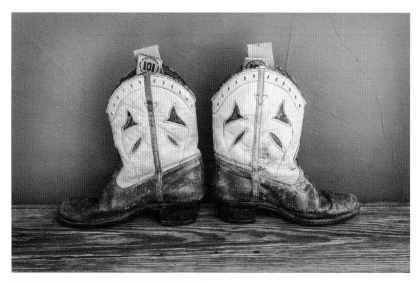

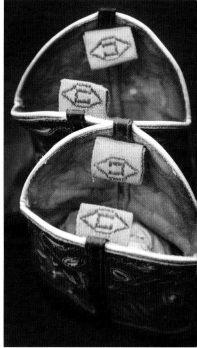

Other well-known boot makers used their own logos. Acme, Goding, Olsen-Stelzer, and Texas are a few of them.

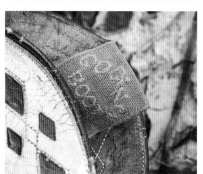

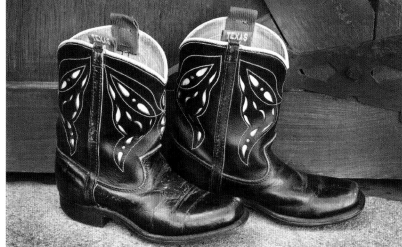

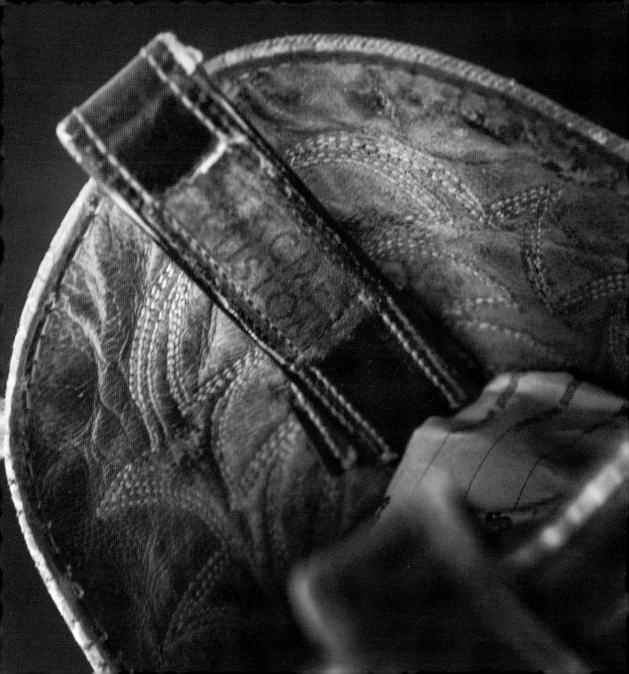

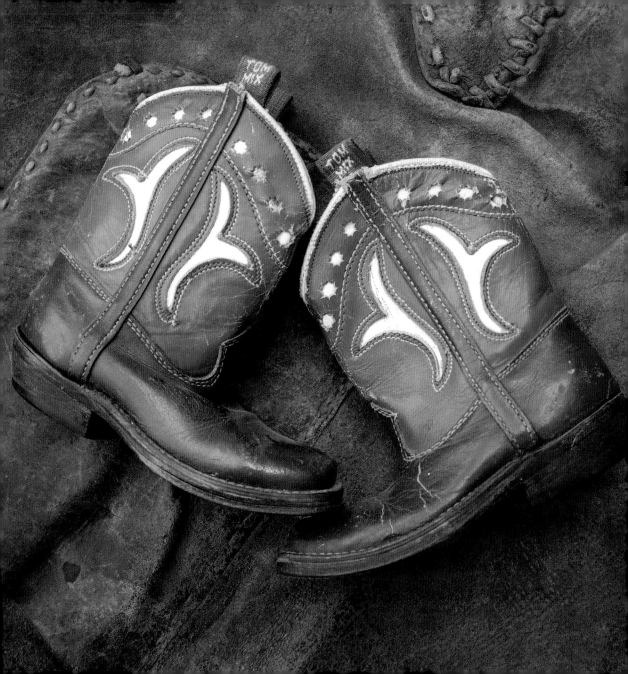

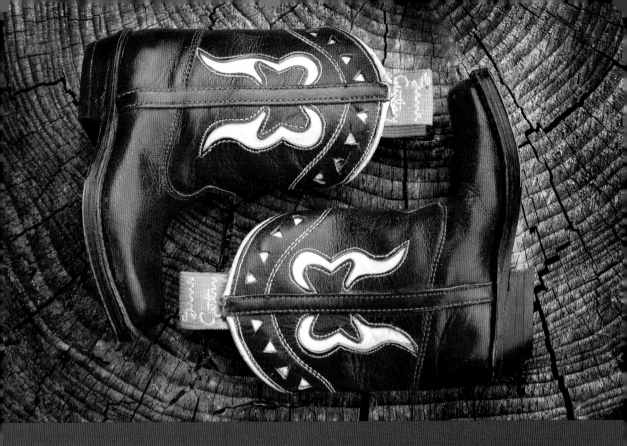

"God bless our Saturday heroes. Blessed is the feeling that comes along with wearing cowboy boots . . . no matter what your age, generation, or gender. Long live the 'cowboy' in us all!"

—ALLEN WILKINSON, Boot Collector

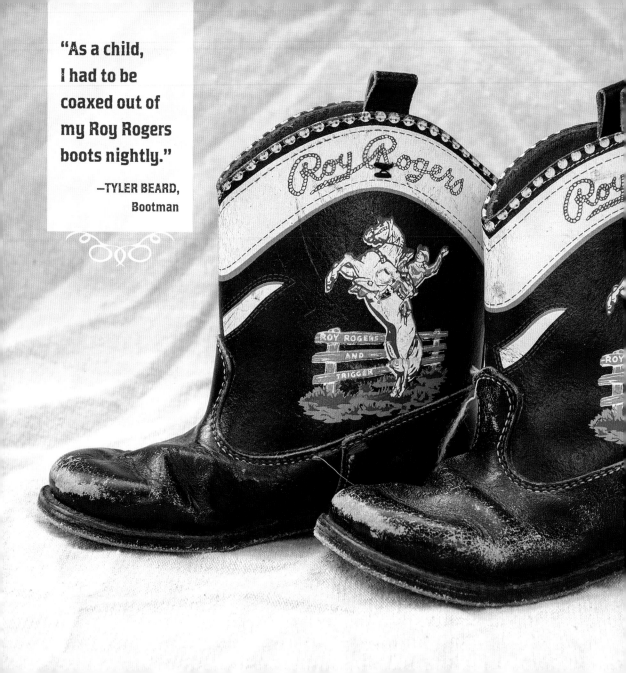

"As a child, I had to be coaxed out of my Roy Rogers boots nightly."

—TYLER BEARD,
Bootman

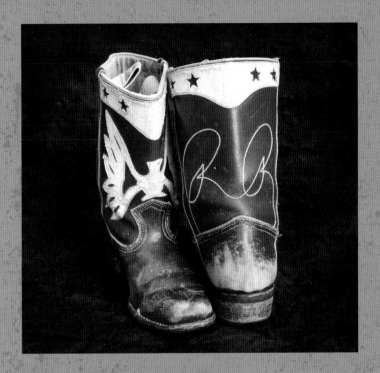

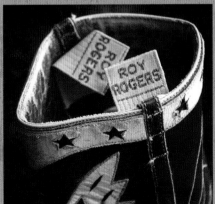

Roy Rogers was idol-
ized by many a child.
Plentiful Roy Rogers
merchandise increased
his popularity.

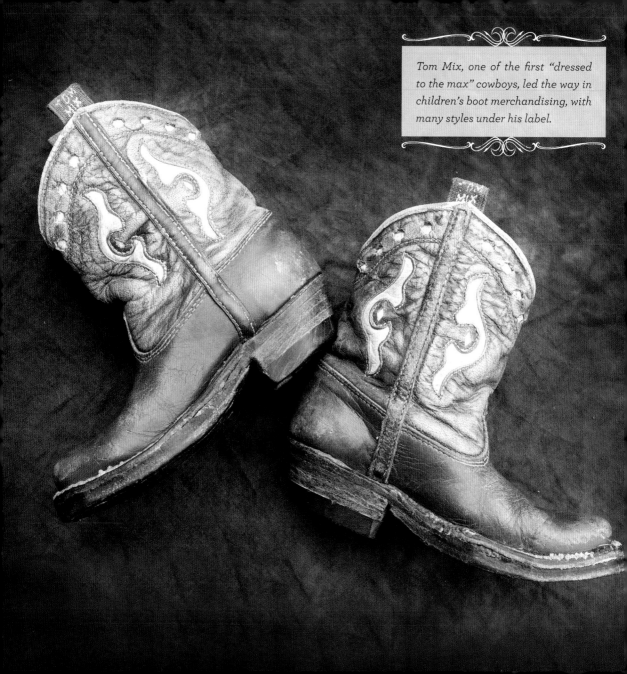

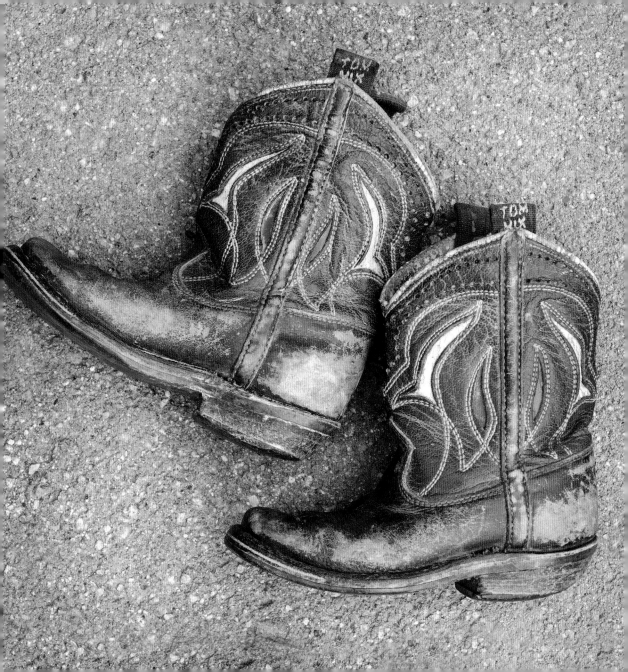

Names and logos were even stamped on the soles of the boots.

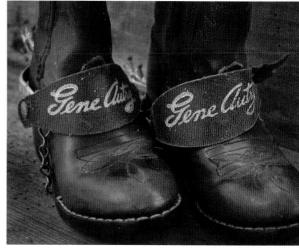

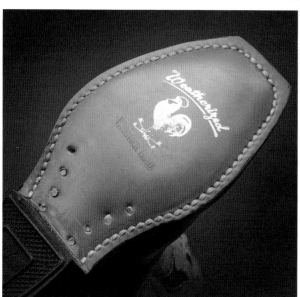

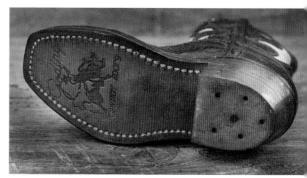

Jim and John Bennett, dressed in full cowboy attire on their black-and-white pony, both turned out to be boot-wearin' lovers of all things cowboy.

John, who started as a blacksmith shoeing his share of ponies, became a western sculptor. Jim, a collector of western antiques, art, saddles, and boots, still has the boots that he and John wore in the photo (right).

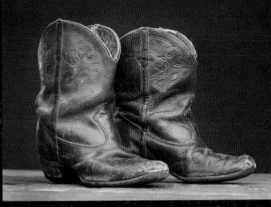

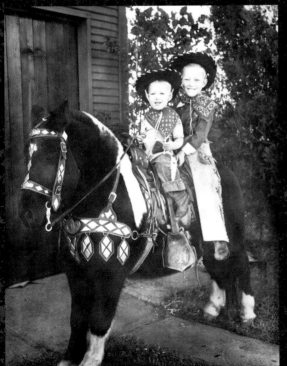

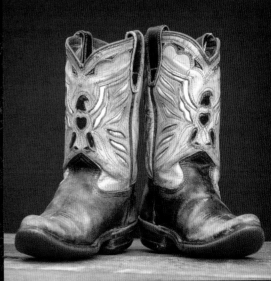

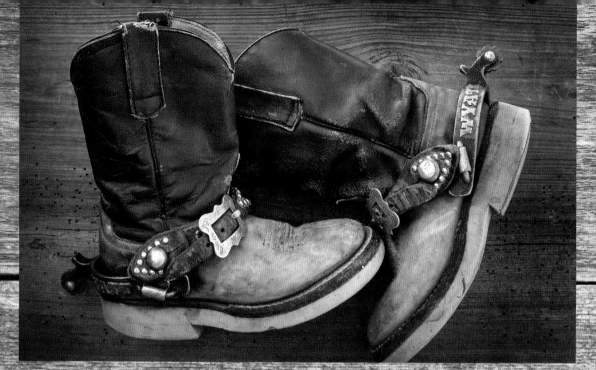

"When I was little I always thought being a cowboy was something that would change my life. What was important for me was to be like my dad."

—WYATT MORTENSON,
Cowboy, age 13

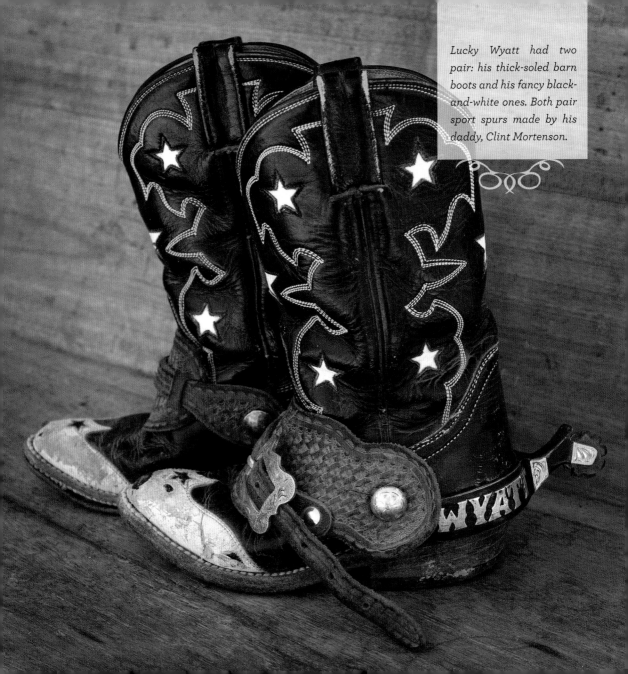

Lucky Wyatt had two pair: his thick-soled barn boots and his fancy black-and-white ones. Both pair sport spurs made by his daddy, Clint Mortenson.

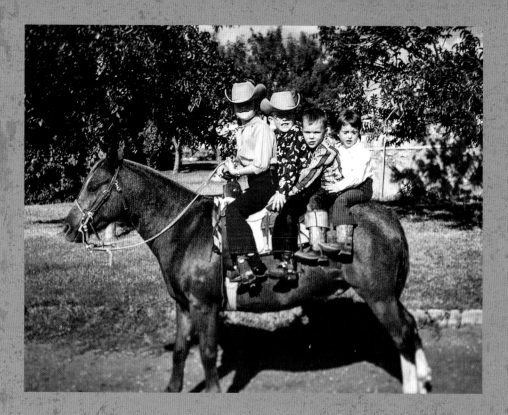

Leddy Family Boot Makers

Since 1922, M.L. Leddy, his brothers, and his descendants have proudly
been making hand-crafted cowboy boots. M.L.'s grandson Wilson
Franklin continues this tradition and adds to the family's rich history.

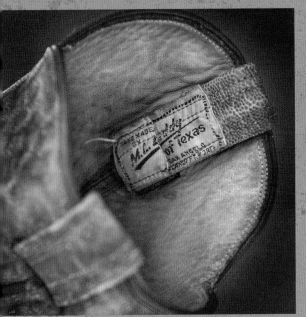
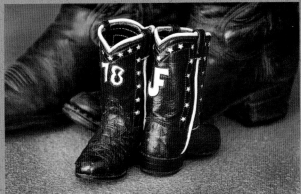
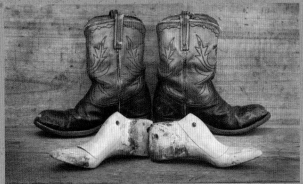
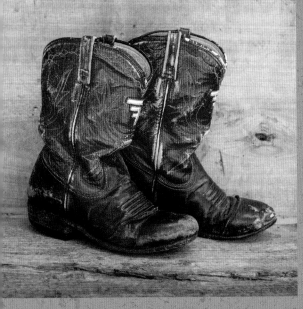
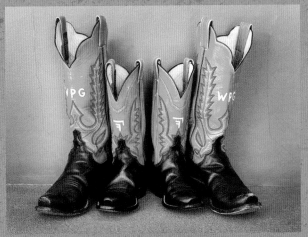

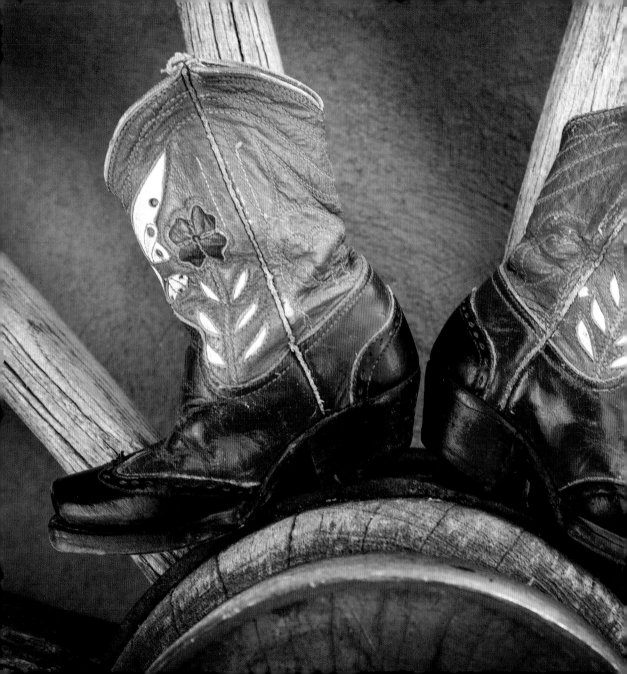

Fancy Dress

Now take it to the next level: upscale bucka-roo and buckerette dress-up boots, with fancy designs just like on Dad's, Grandpa's, or a favorite aunt's. Multicolored leather, wingtips, exotic materials, horses, and bright colors of the rainbow take a boot from plain to fancy.

Where could a youngster wear fancy boots? To a wedding, a community dance, a convention, or the rodeo. Even to church on Sunday. Real cowkids want a pair for work and a pair for dress.

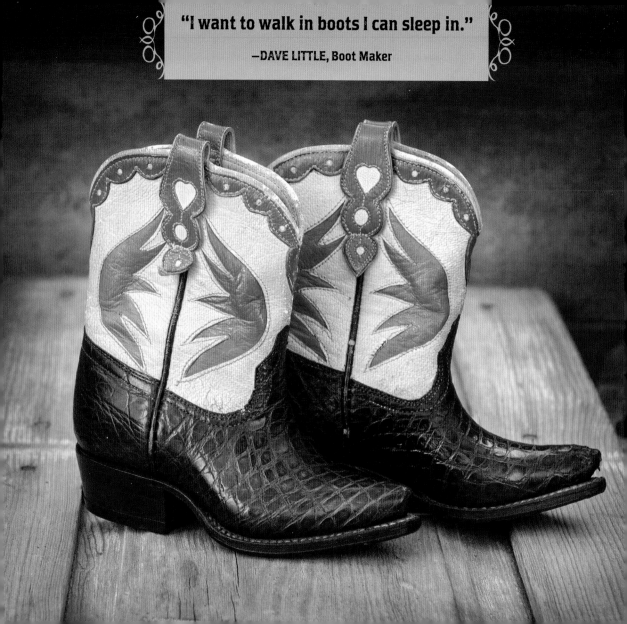

"I want to walk in boots I can sleep in."

—DAVE LITTLE, Boot Maker

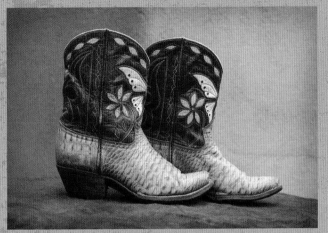

FACING: *Dave Little made some pretty fancy boots for his son Dave.*

LEFT: *These are made for stylin'.*

BELOW: *Three new Stallion boots destined to be future collectibles.*

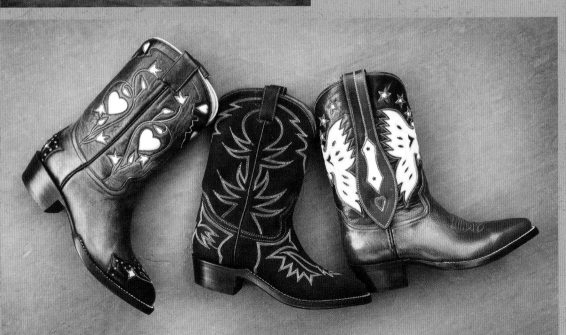

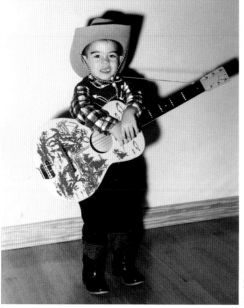

© Hilda Stuart

"My mother, Hilda, took this picture in 1961. The photograph pretty much tells the story of my entire life. When I see a current image of myself, nothing has really changed since back then. I'm still wearing cowboy clothes and cowboy boots and playing a cowboy guitar, looking to show out to whomever will listen."

—MARTY STUART

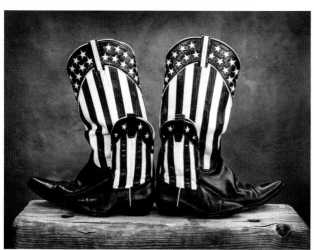

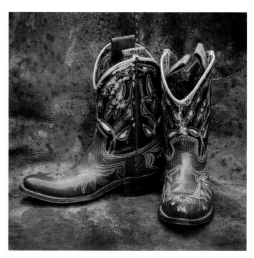

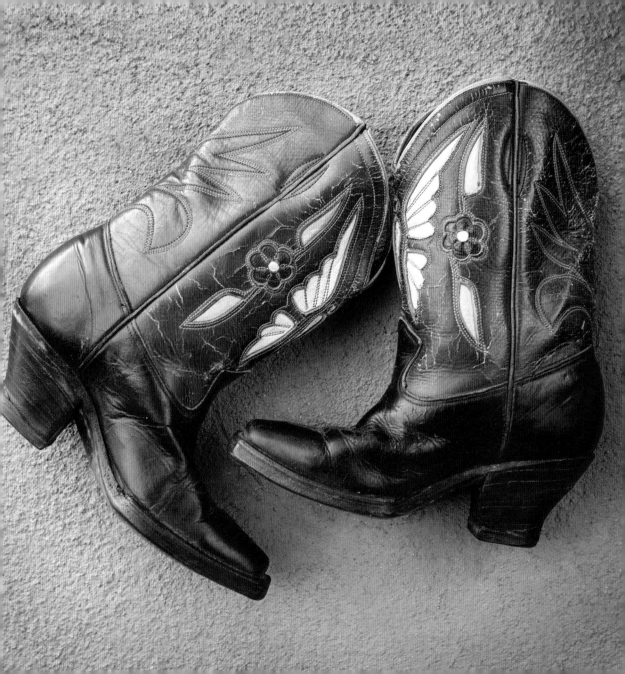

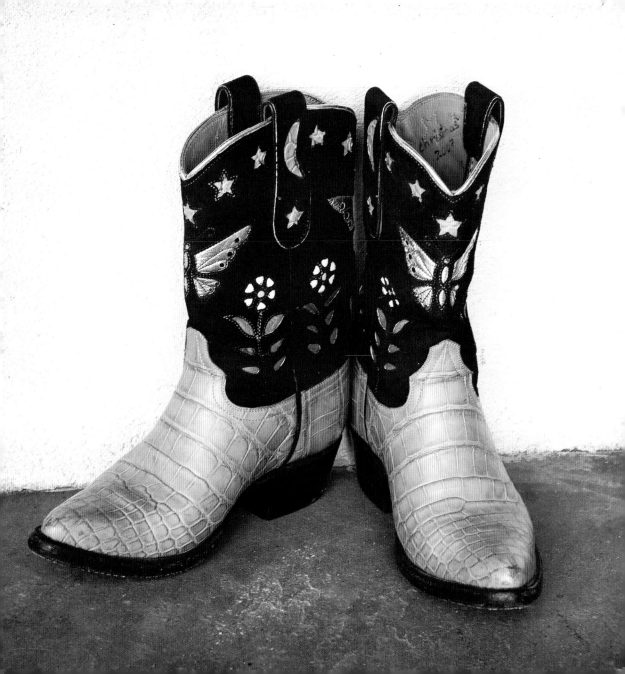

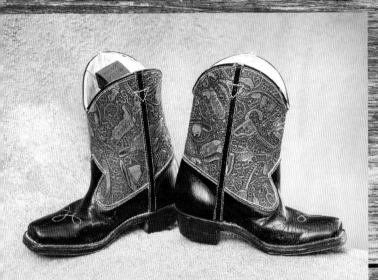

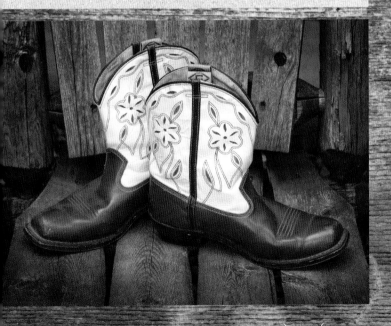

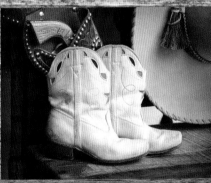

FACING: *What does a boot maker make for his daughter, Mirabella? Pink boots by Pedro Muñoz.*

Three other pairs are fancy and fun.

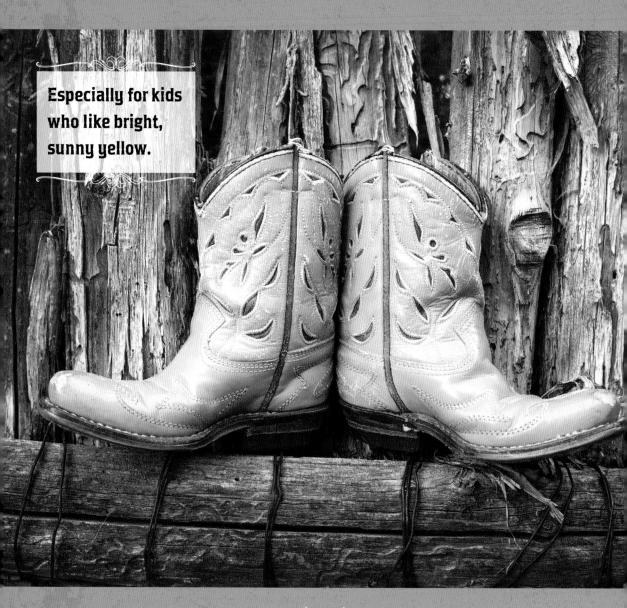

Especially for kids
who like bright,
sunny yellow.

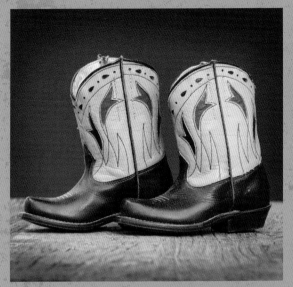

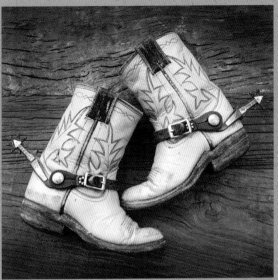

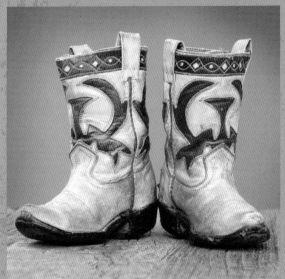

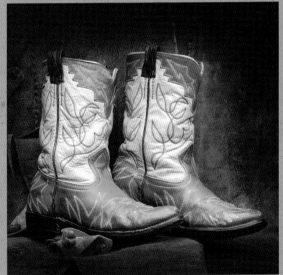

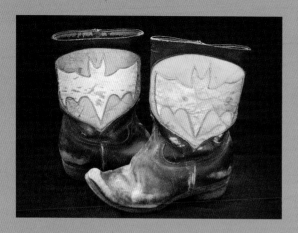

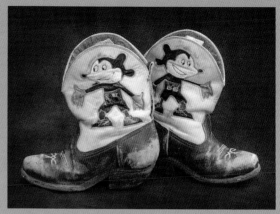

Cavender Family

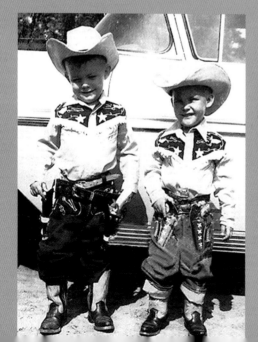

The Cavenders are truly a family operation, living the western lifestyle on working Texas ranches. Mike, a collector and boot historian, has a wide variety of one-of-a-kind examples of the "best of the best" boots ever made.

"Have Gun, Will Travel and Bonanza were our favorite TV shows. Rooster Barnwell and Dickie Davis were our favorite cowboys. We rode Smoky and Spot."

—MIKE CAVENDER

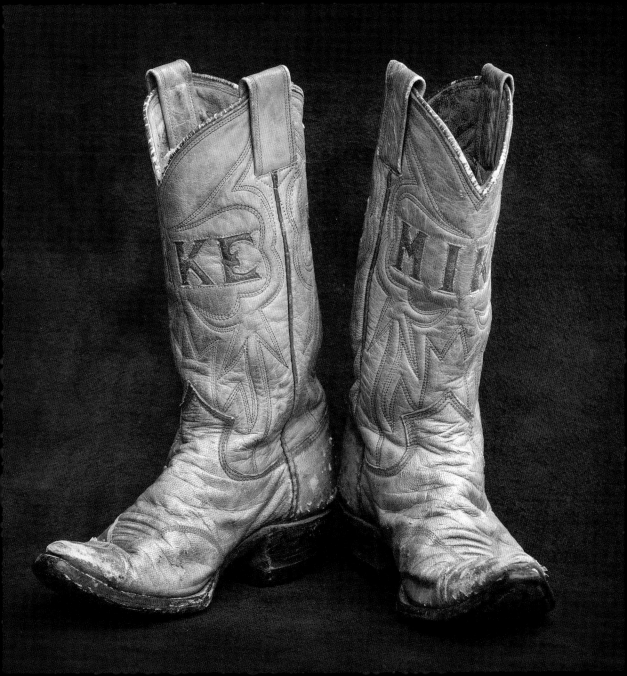

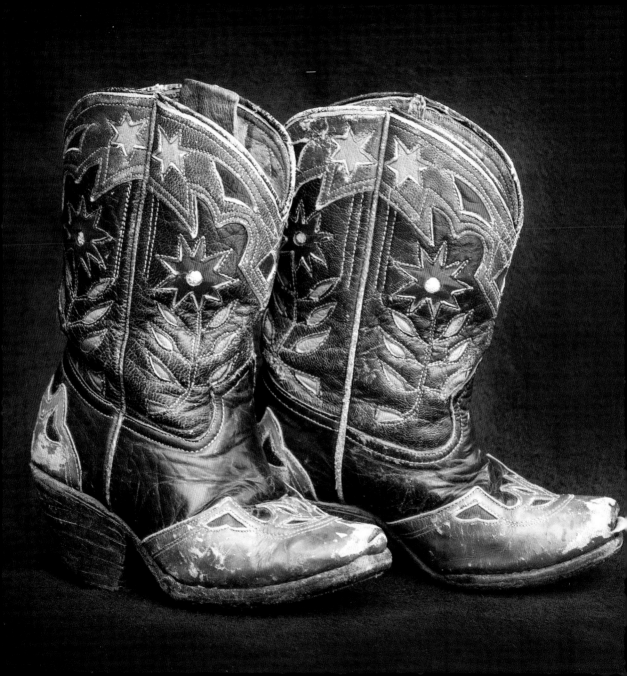

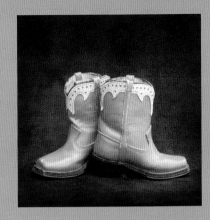

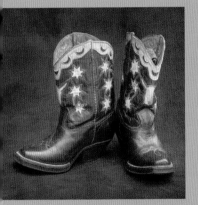

Custom mini cowboy boots made by Greg Carmack for Mike Cavender's son Cooper, with brands, logos, and birthdays inlaid and overlaid on his boots.

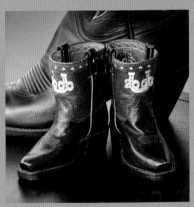

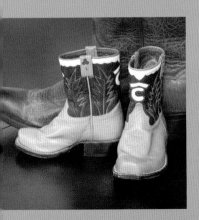
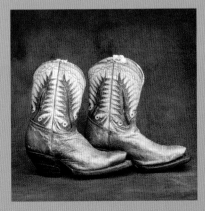
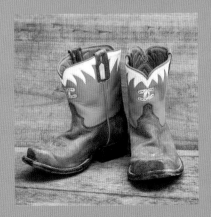

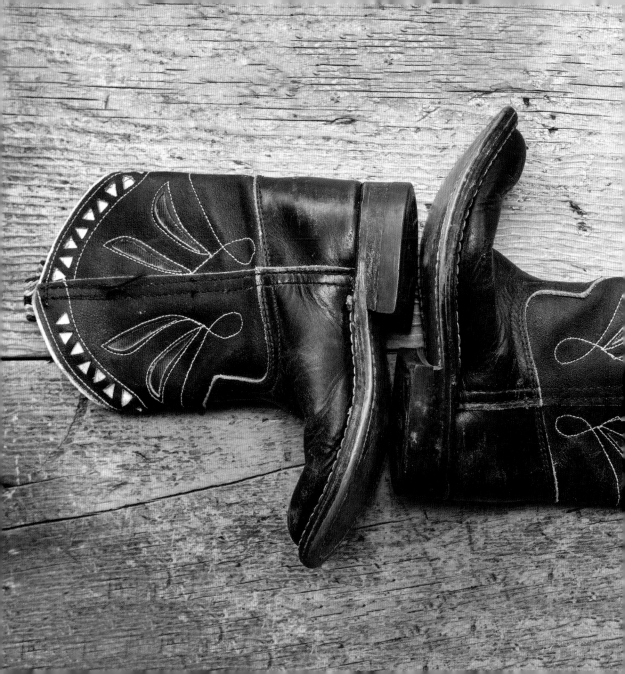

Inlay/Overlay/ Stitching

Stitch on some cool stuff.

Inlay some colored designs.

Overlay any image or icon.

Imaginations gone wild!

Dude up those boots, add some flash and dash for a more personal statement.

Make the neighborhood buddies jealous!

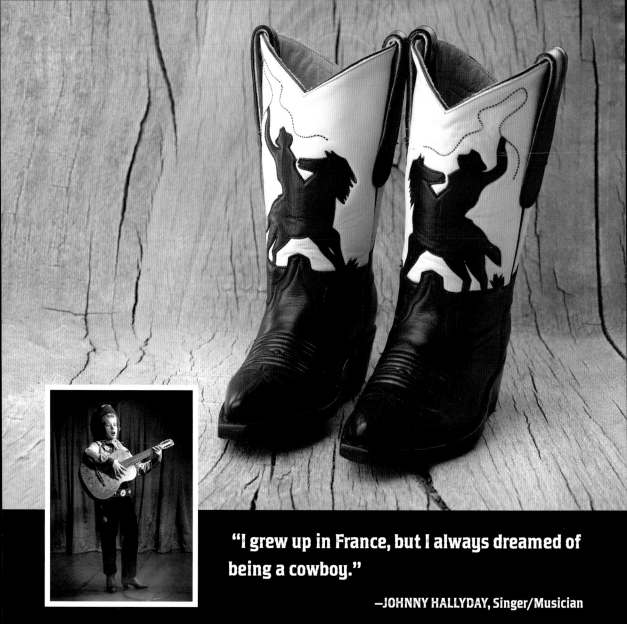

"I grew up in France, but I always dreamed of being a cowboy."

—JOHNNY HALLYDAY, Singer/Musician

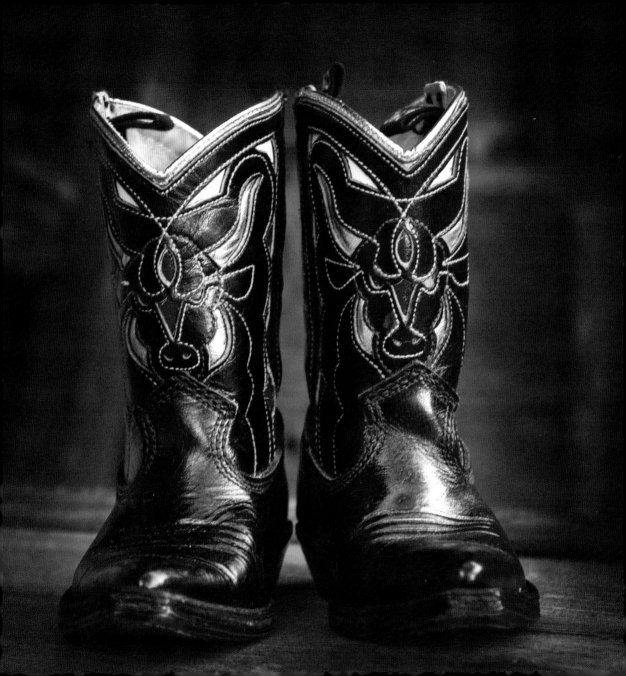

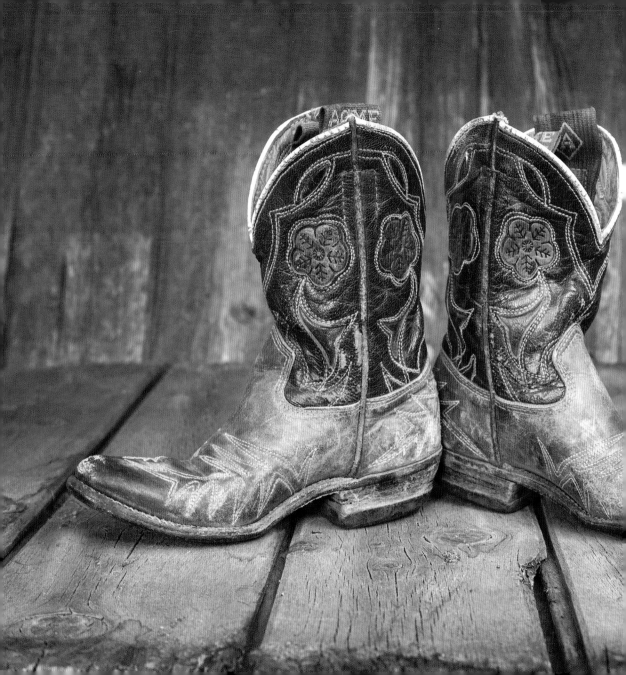

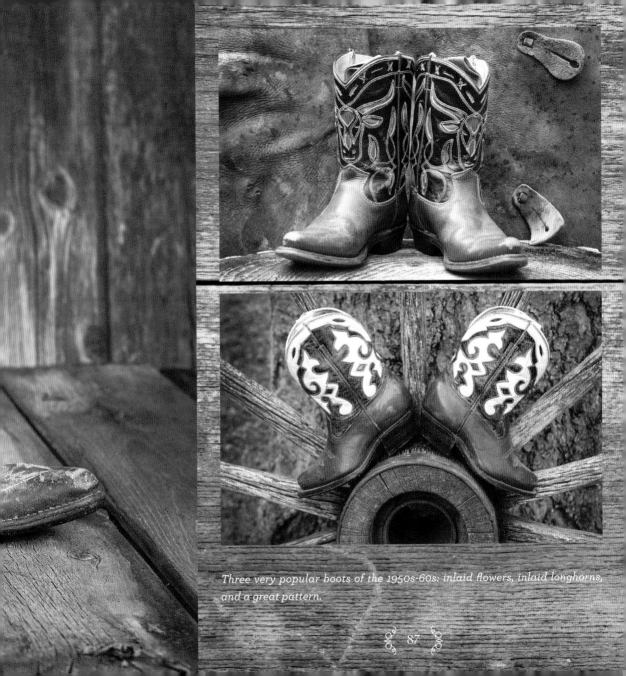

Three very popular boots of the 1950s-60s: inlaid flowers, inlaid longhorns, and a great pattern.

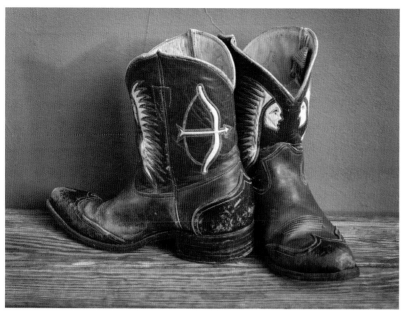

An Indian head with bow and arrow is stunning on a boot with a simple toe and heel cap. Below, little cowboy Jimmy.

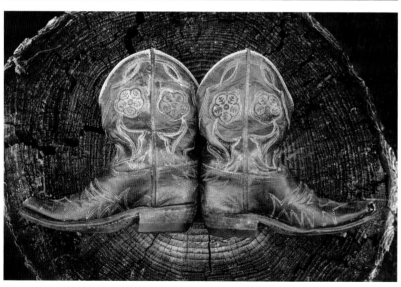

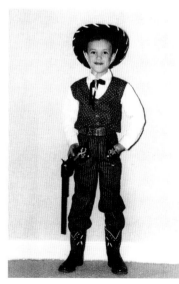

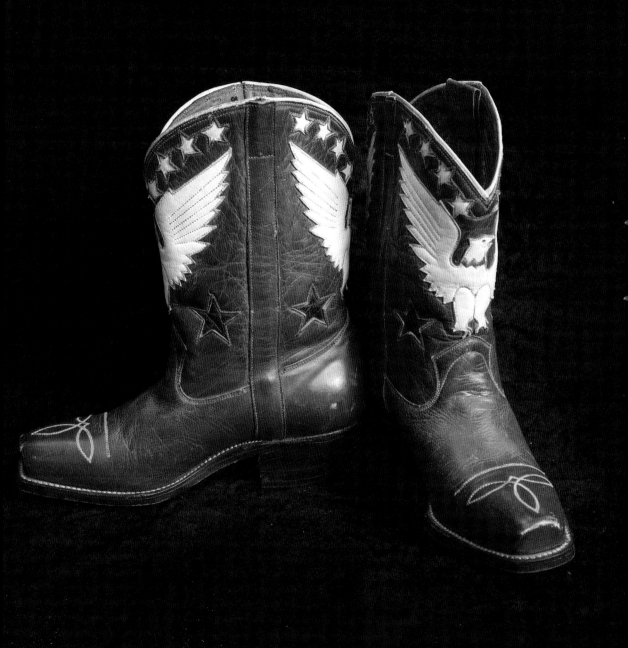

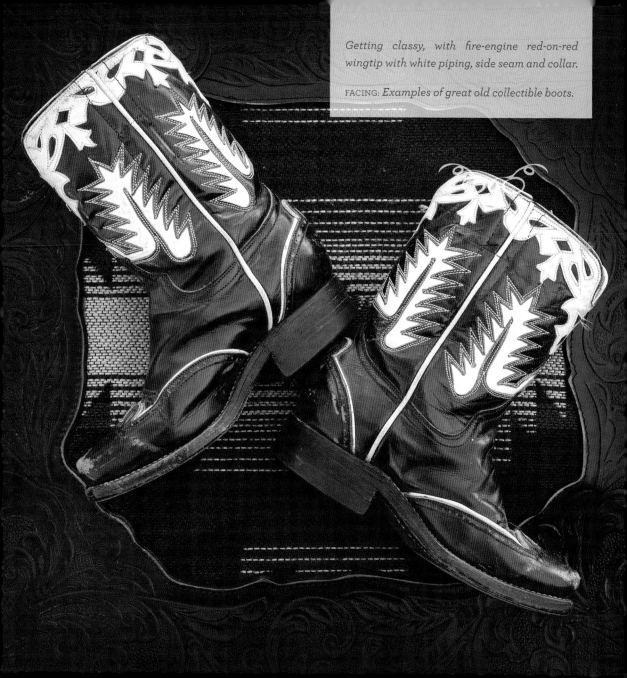

Getting classy, with fire-engine red-on-red wingtip with white piping, side seam and collar.

FACING: *Examples of great old collectible boots.*

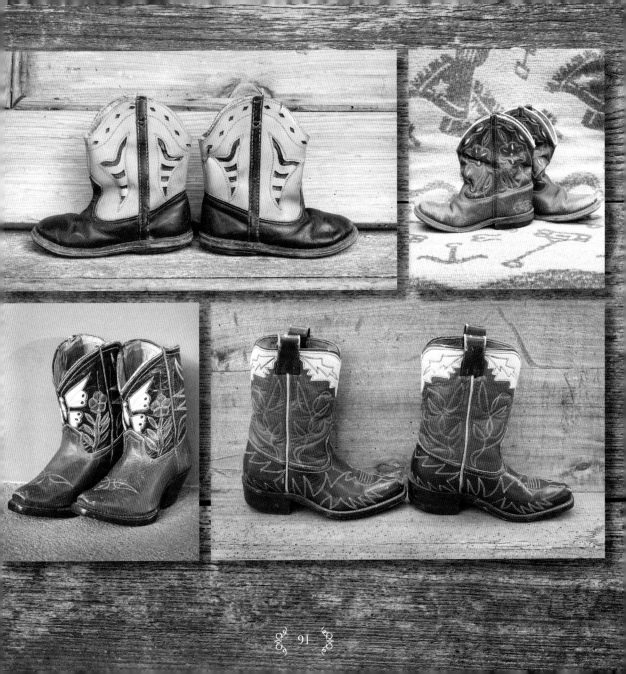

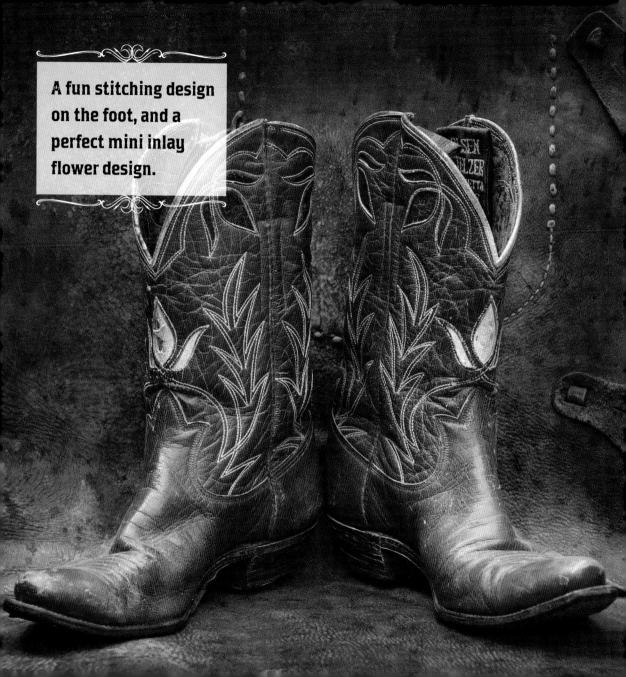

A fun stitching design on the foot, and a perfect mini inlay flower design.

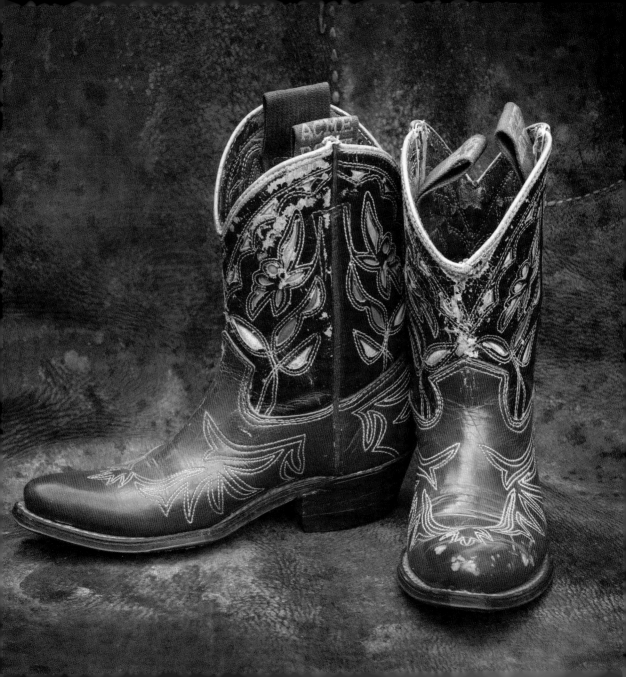

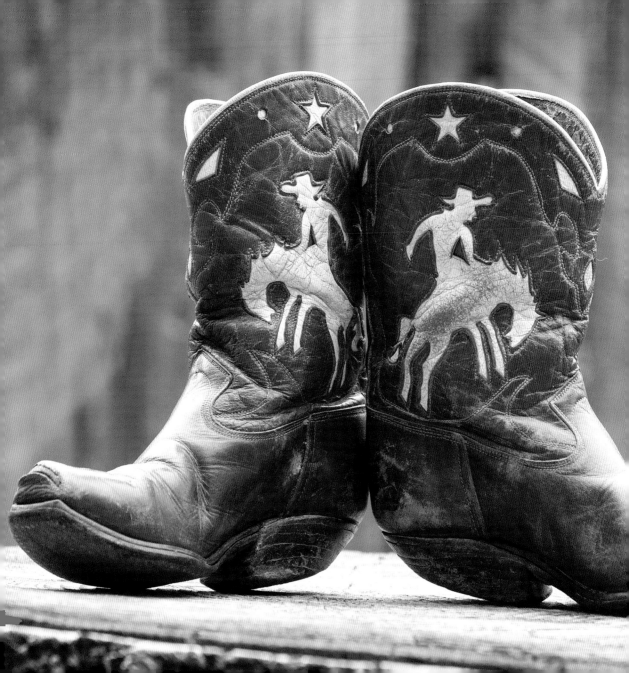

Ranch Life

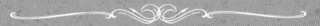

The emblems of western life become images on boots for younger ranch hands: buckin' bronc, steer heads, horse heads, or eagles soaring over the open range.

Whether the chore is to muck out stalls, feed the calves, work the cattle, spruce up an animal for the 4-H show, or help with branding, ranch kids fill big boots and they walk tall. Why not a pair of boots sporting icons of the life on the ranch?

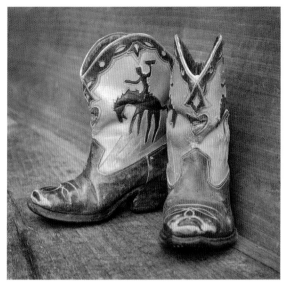

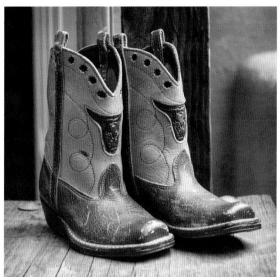

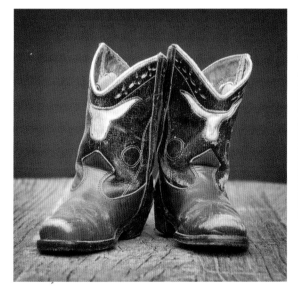

Wear adds character. The longhorn pair, far left, has seen many miles.

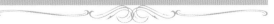

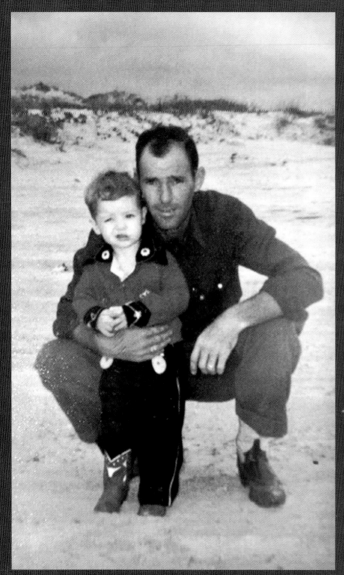

"I was born in Coleman, Texas. It's pure, no-nonsense West Texas. My father was the foreman of a small ranch.

"I don't ever remember seeing him in anything but boots. There were rattlesnakes out there. To this day I knock the backs on the floor before I put mine on just like he did. He did it to check for scorpions that might have taken up residence overnight down in the toes.

"He wore a hat too.

"He sang and played on weekends in a country band called the Fox Four Five for the radio station in Abilene, Texas.

"He was my hero and I wanted to grow up to be like him. Boots were manly footwear.

"I got my first pair as soon as I could walk. They were red with a white steer head on the tops. Later I graduated to what are my standard "go-to's" to this day—tan roughouts.

"Today I don't know how many pairs of boots I have. Hundreds.

"It was way before the COWBOY tattoo."

—RONNIE DUNN,
Country Artist

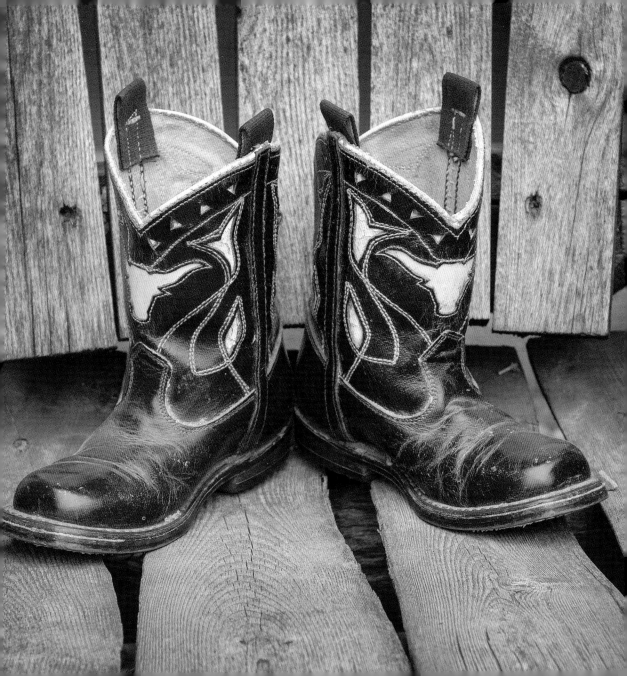

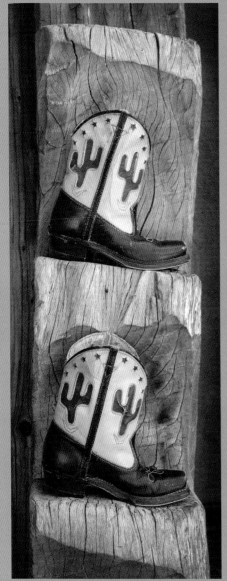

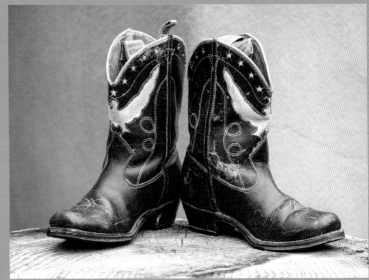

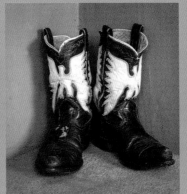

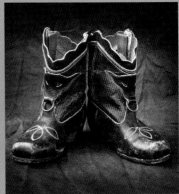

Classic western images: saguaro cactus, spread-winged eagle and the ubiquitous bovine.

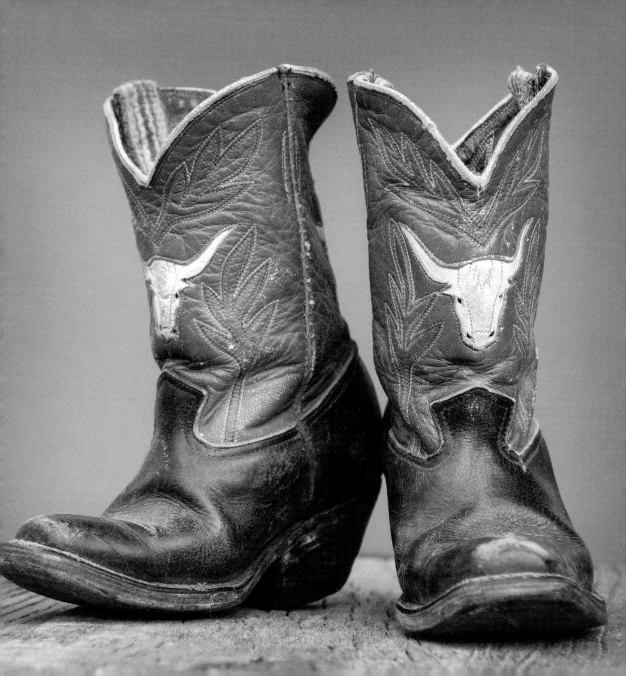

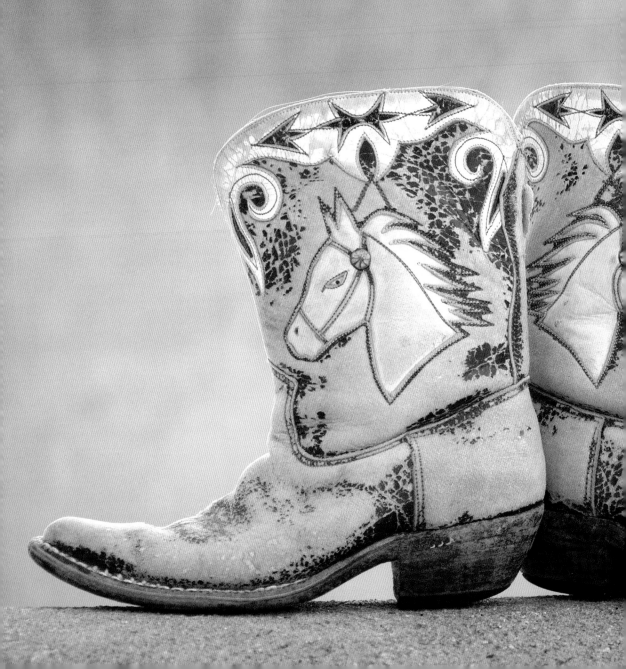

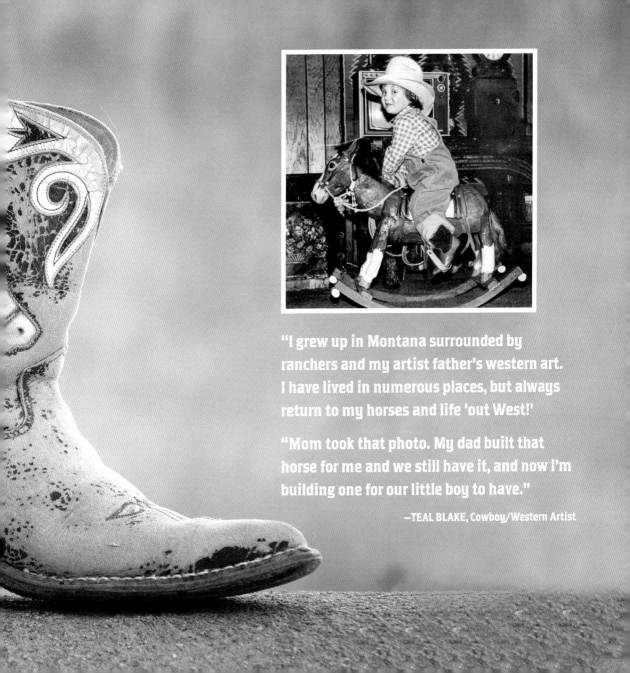

"I grew up in Montana surrounded by ranchers and my artist father's western art. I have lived in numerous places, but always return to my horses and life 'out West!'

"Mom took that photo. My dad built that horse for me and we still have it, and now I'm building one for our little boy to have."

—TEAL BLAKE, Cowboy/Western Artist

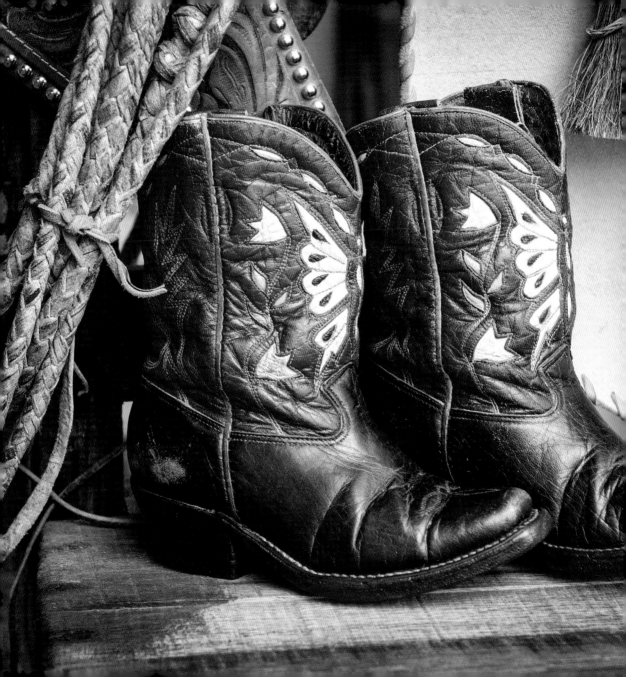

Everybody's Favorite Color

Red tops. Red bottoms. Red all over. It's the power color!

Buckaroos ride a little taller, buckerettes walk a little sassier in red.

Cowboys love colors on their chaps, shirts, and for sure on their boots. Uncover the tops from under their jeans and you will see designs in green, yellow, blue, white, and purple, but the most popular color for boot tops is red.

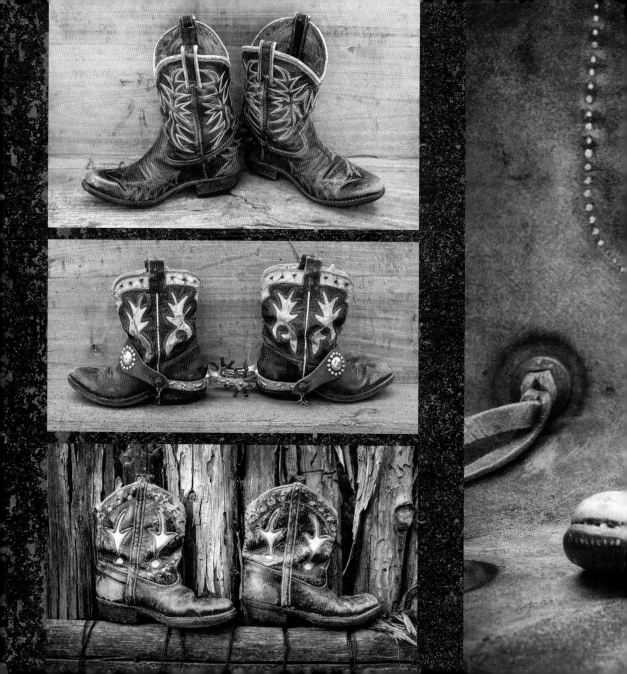

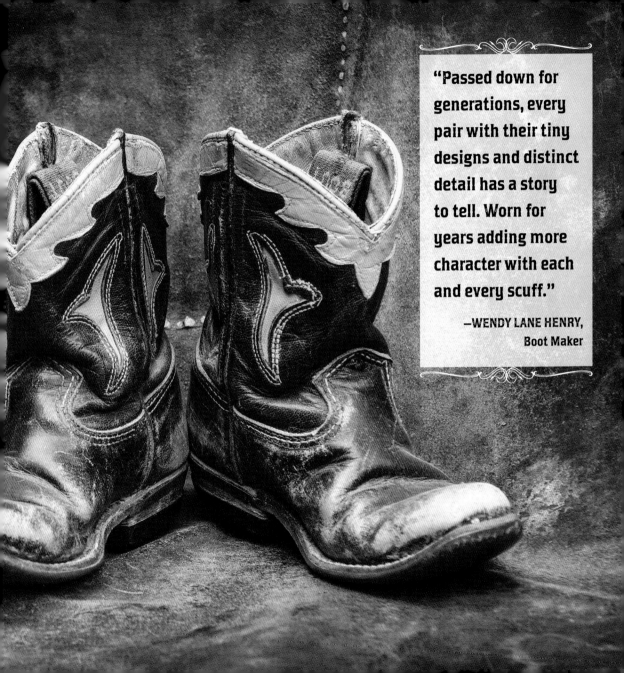

"Passed down for generations, every pair with their tiny designs and distinct detail has a story to tell. Worn for years adding more character with each and every scuff."

—WENDY LANE HENRY,
Boot Maker

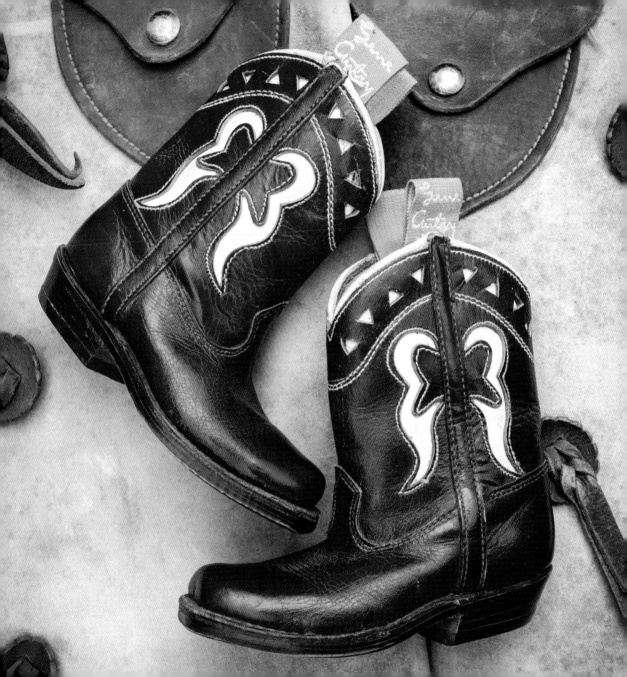

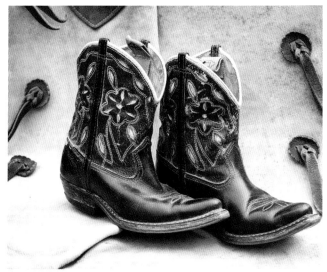

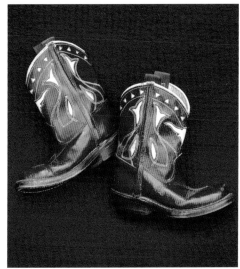

Since Gene Autry had red boots, little buckaroos had to have the same. But the variations were limitless.

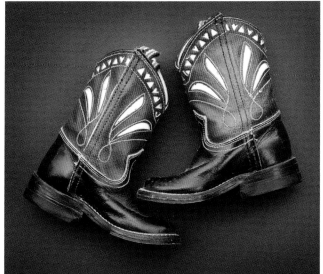

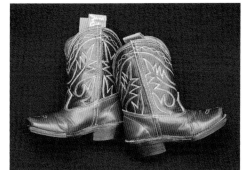

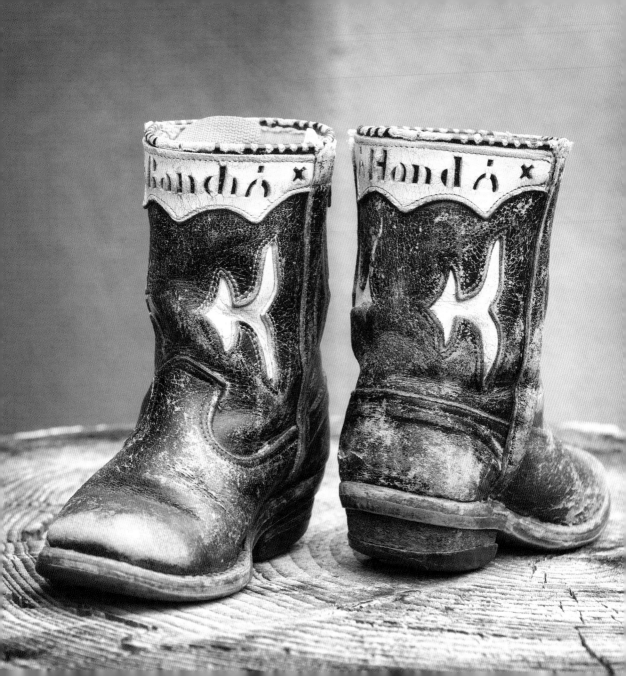

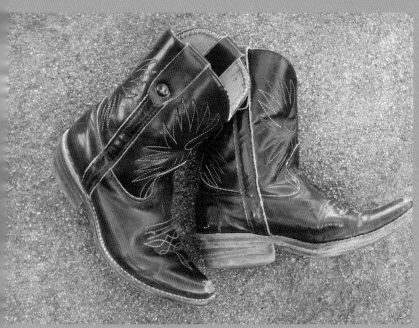

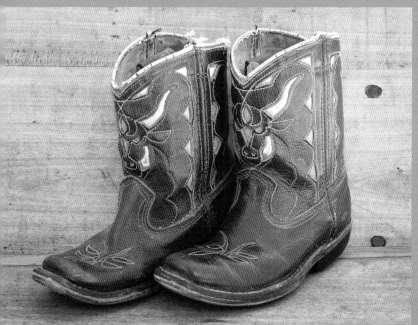

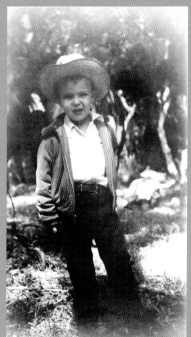

'BR, Age 7. 1957.
Ready to roll.'

"From the first time
I saw a horse— I
knew. If there's a
horse attached to
the deal, I'm in."

—BILL REYNOLDS, Writer

These examples of vintage boots show some of the evolution.

RIGHT: *A fancy green butterfly and some rocking tall heels.*

FACING: *A simple design, toe bug, scalloped top, and a silver button.*

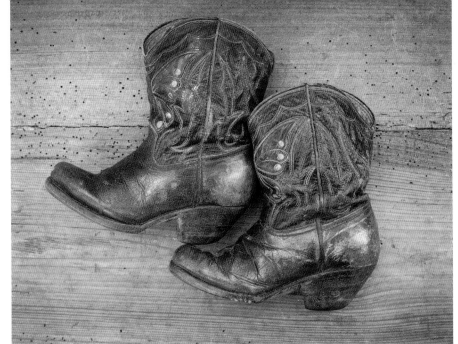

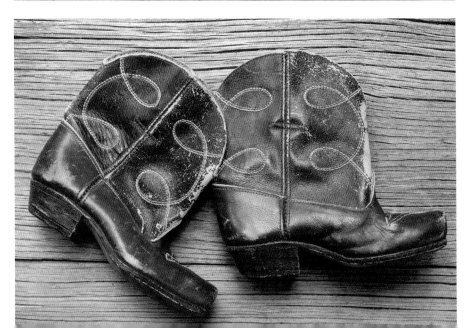

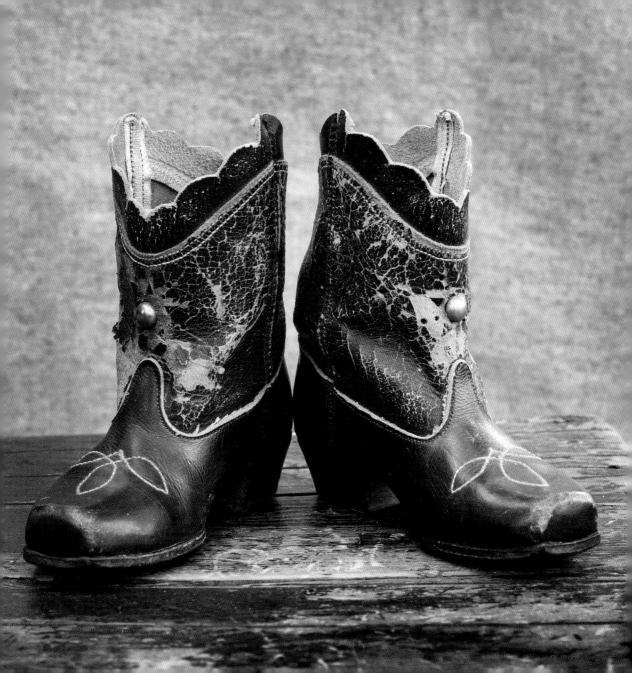

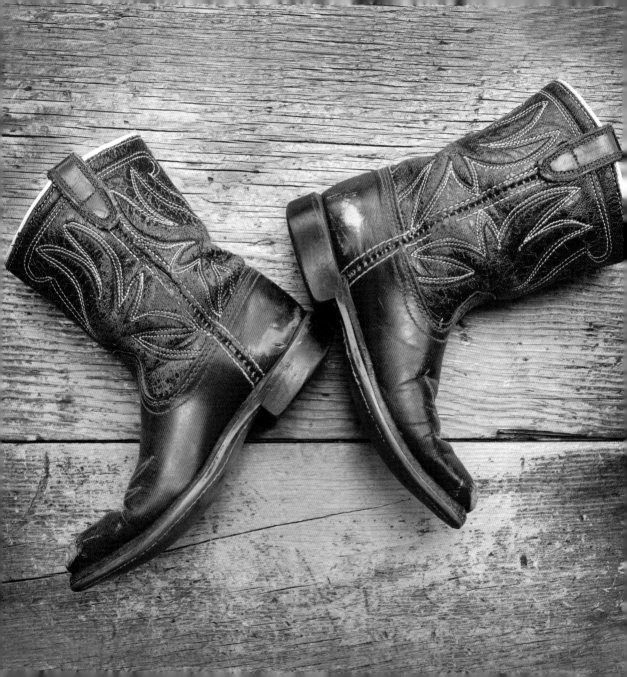

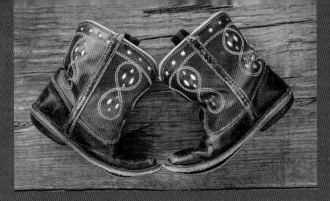

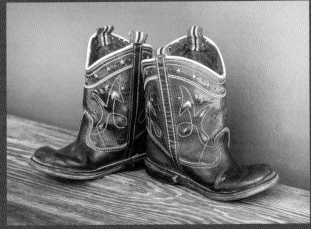

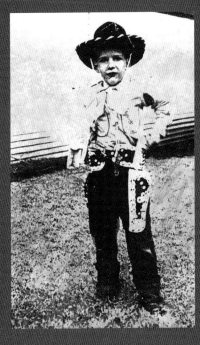

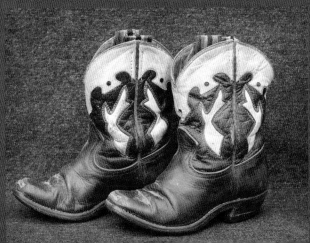

"I fantasized about riding in and making things right. The hero who solved the problem, then rode on."

—JOHN WARE,
Musician/Drummer, Reckless Red

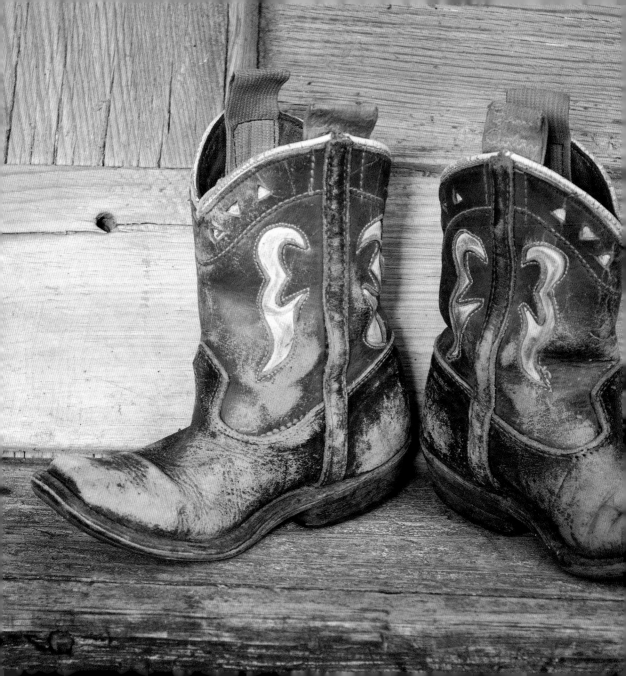

Rode Hard &
Put Up Wet

Nicks. Scratches. Gouges. Holes.

Worn-out toes and worn-off heels.

Lived-in cowkid boots that saw all weather and seasons acquired character. It is rare to find pristine vintage kid boots. Crawling on your hands and knees, chasing around the "range," over rocks and through streams, morning 'til night, took a toll on favorite footwear.

Next: re-sole, re-heel, stitch 'em up! All ready to go for another adventure and another day.

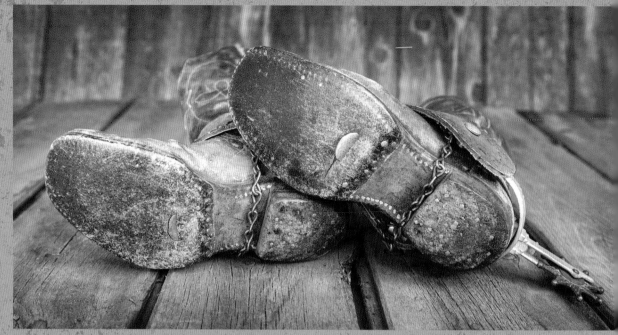

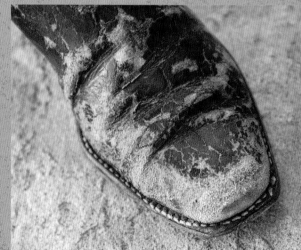

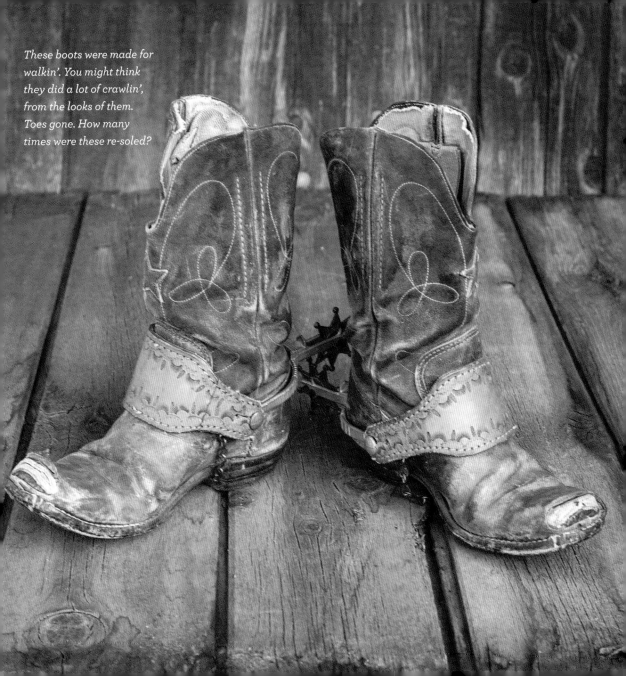

These boots were made for walkin'. You might think they did a lot of crawlin', from the looks of them. Toes gone. How many times were these re-soled?

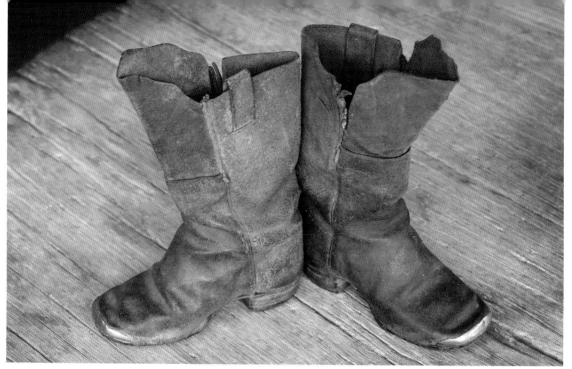

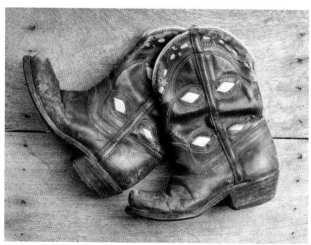

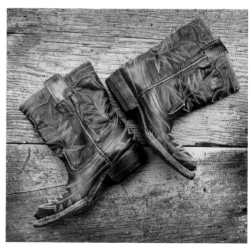

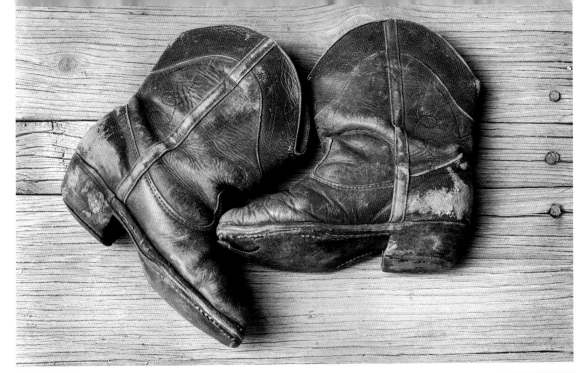

FACING ABOVE: *Civil War–era child's boots, with wear from many years. Other boots here show signs of being well worn and well loved.*

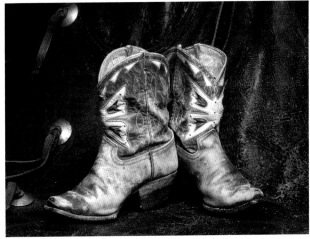

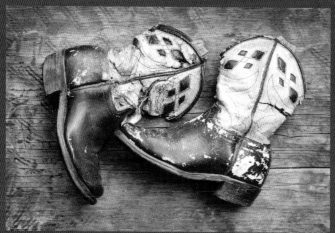

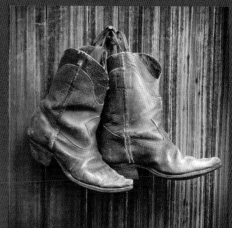

Tops cracked.
Toes gone.
Loved to death!

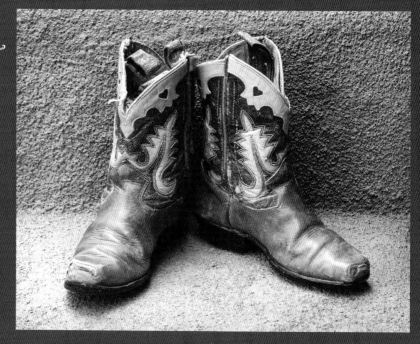

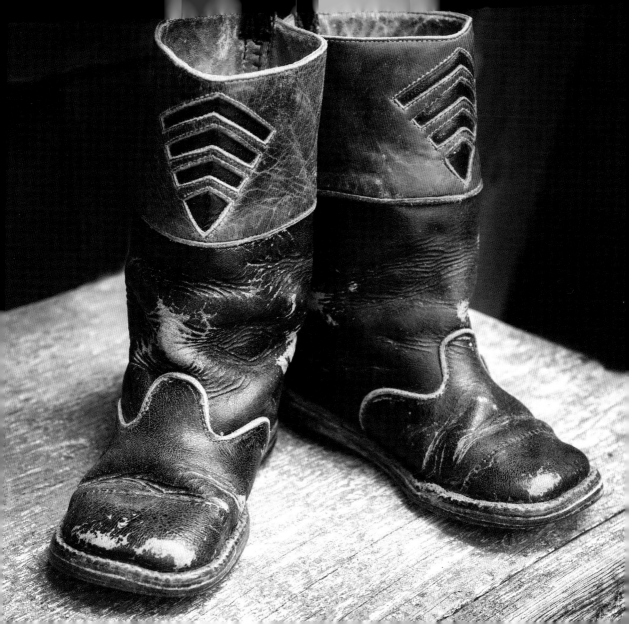

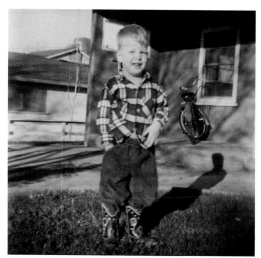

"That's me in my cowboy boots, and on the porch, my steed, Star."

—LEE DOWNEY,
Jewelry Designer/Artisan

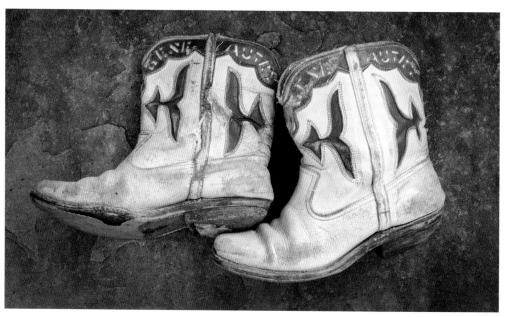

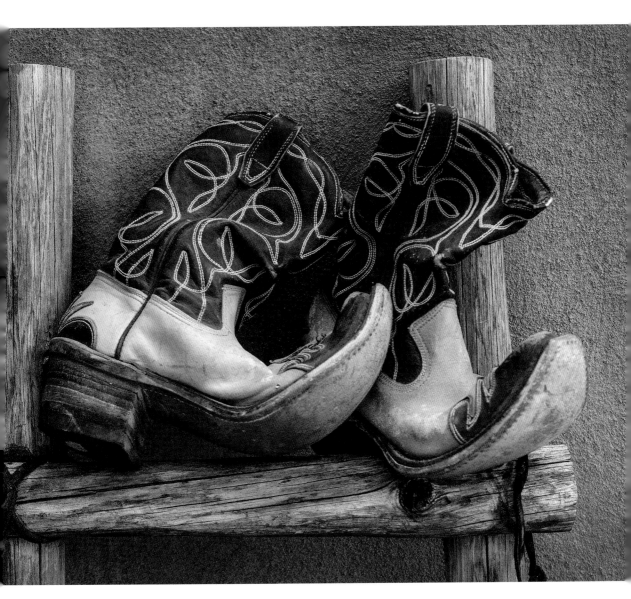

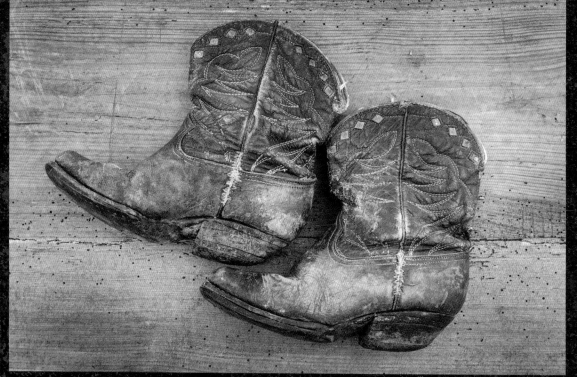

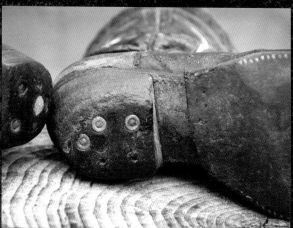

Just stitch 'em up for more
years of buckarooing.

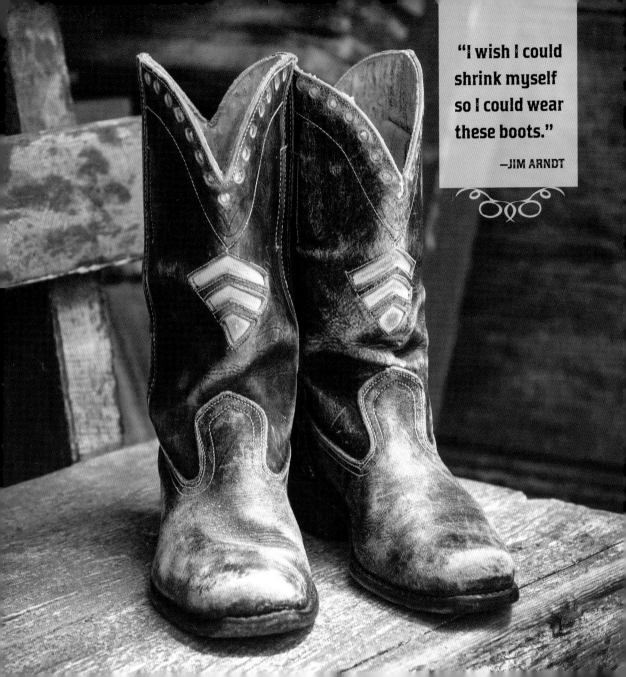

"I wish I could shrink myself so I could wear these boots."

—JIM ARNDT

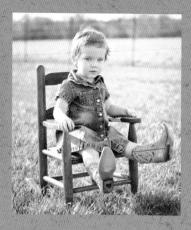

To all little buckaroos

19 18 17 16 15 5 4 3 2 1

Text and photography © 2015 Jim Arndt

Published by
Gibbs Smith
P.O. Box 667
Layton, Utah 84041

1.800.835.4993 orders
www.gibbs-smith.com

Designed by Melissa Dymock
Printed and bound in Hong Kong

Gibbs Smith books are printed on either recycled, 100% post-consumer waste, FSC-certified papers or on paper produced from sustainable PEFC-certified forest/controlled wood source. Learn more at www.pefc.org.

Library of Congress Control Number: 2014956273

ISBN: 978-1-4236-3952-7